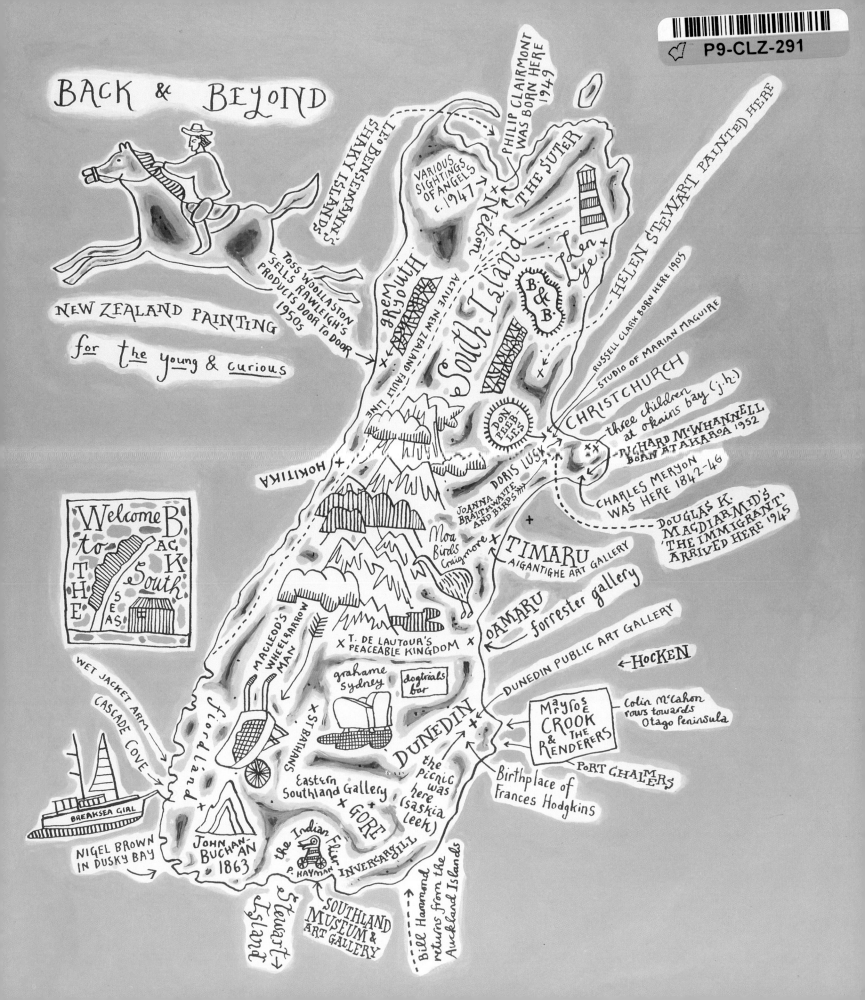

Back and Beyond

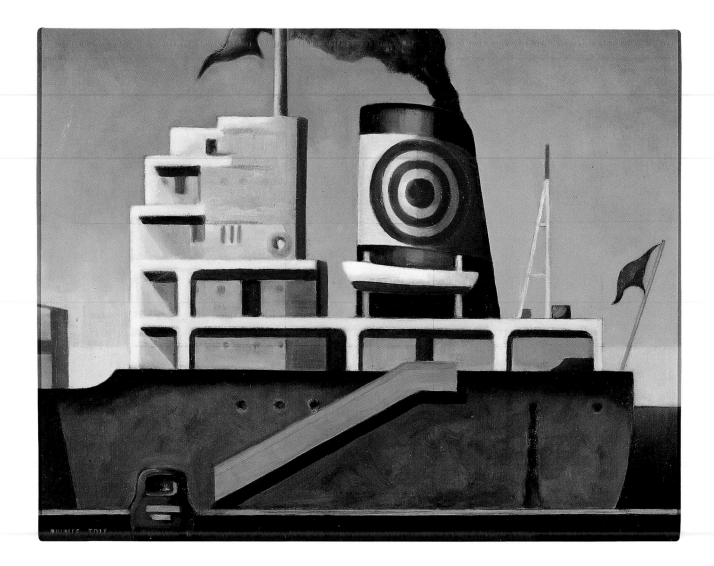

Back and Beyond

NEW ZEALAND PAINTING FOR THE YOUNG AND CURIOUS

GREGORY O'BRIEN

AUCKLAND UNIVERSITY PRESS

This book is dedicated to the memory of John Drawbridge (1930–2005),
painter, printmaker, muralist, teacher

'I wouldn't want to be a painting because you would just hang
on the wall and you wouldn't have thoughts or feelings.'
– Carlo Bornholdt, aged eight

PREVIOUS PAGE: KAISEI MARU (1967–75), an oil on hardboard painting by Charles Tole (1903–88). Art is all about setting sail for the unknown and discovering new worlds. That is just what Charles Tole is doing in this painting: the chimney is belching smoke and the big ship is about to cast off. Around the time Charles Tole painted *Kaisei Maru*, New Zealanders were starting to get used to living in this part of the world. Also, maybe, they were starting to have some fun. The car parked on the wharf resembles a child's toy. A fair wind is blowing the flags. New Zealand art was setting sail for new worlds, both real and imagined. All aboard.

Contents

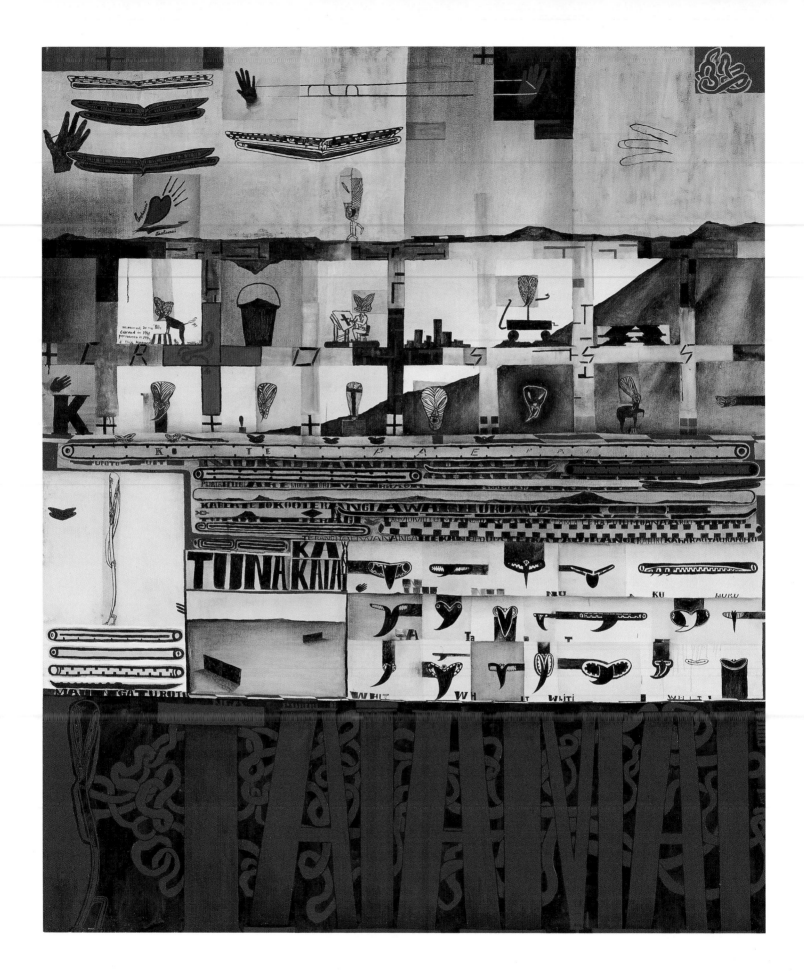

The Shaky Islands – an introduction

When I was living in Sydney back in the 1980s, New Zealand was often called the 'Shaky Islands' – not only by Australians but by New Zealanders I met over there. The 'Shaky Islands' label was mostly used in a mocking way and probably stemmed from the fact that New Zealanders lived on a narrow, unstable landmass – shaky ground compared to the vast continent of Australia. As a proud 'Shaky Islander', the nickname, however, always struck me as good and overwhelmingly positive. Leaving aside, for the moment, the shaking because of earthquakes, volcanic eruptions, the geysers and mudpools of Rotorua and the Wellington wind, New Zealand is an energetic, go-ahead sort of country, where everything is moving and changing all the time. It is also a young nation, and a small one (on a global scale of things). If the country is shaking, I think it is more from excitement than from nervousness. Much in our favour, New Zealand still contains a sense of possibility, surprise and discovery. Those are definitely the elements that you will find in the art in this book – paintings, prints and drawings produced by New Zealanders not only in recent years but going back two centuries or more.

When I hear the term 'Shaky Islands' these days it brings to my mind the shaking, rattling movement of Len Lye's *Fern People* (page 17), the bubbling, fuming landscapes of Jane Pountney and Alexis Hunter (pages 18 and 19) and

Drawing for the *School Journal* (late 1940s), by Juliet Peter (born 1915).

OPPOSITE: TUNA (1996), an oil on canvas painting by Shane Cotton (born 1964, Ngapuhi, Ngati Rangi, Ngati Hine, Te Uri Taniwha). A tuna is another name for an eel, so maybe the exact meaning of Shane Cotton's painting *Tuna* is deliberately slippery. In this painting, Shane is digging around for signs and symbols in nineteenth- and twentieth-century Maori culture and, in doing so, he digs up quite a lot of European culture as well. The last 200 years have been a great period of things getting mixed together. In the 1800s, many collectors came to New Zealand to gather objects and take them back to England or Europe, where they ended up in museums and private collections. In *Tuna*, Shane hands a lot of these treasures back to us: patterns from Maori carvings, fragments of words in English and Maori, a mountain and some very flat landscapes. There is also, at the top of the picture, a diagram of the kind of Maori string game, or whai, children sometimes play.

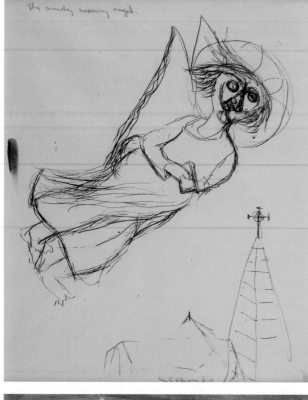

the wavering outline of *The Sunday Morning Angel*, a pen and ink drawing by Colin McCahon. This is not the kind of shining, bright-eyed, holy angel you would find in a painting from the Italian Renaissance. Coming in to land, the angel's feet look as if they are kicking – as if he is trying to feel where the ground is. The lines around the angel's face, clothing and feet make it look as if he is shaking, vibrating – or maybe he has hit some air turbulence. The church steeple looms like an air traffic control beacon. The imaginative energy you can feel in this drawing is something artists tap into and gather – in much the same way a wind farm gathers wind. This is the power that we need!

New Zealand is a land of the unexpected. That was how it would have been for the first Maori who arrived here – especially when they encountered 3-metre-tall moa birds striding about. It would also have been so for Captain Cook's artist Sydney Parkinson, who made many drawings of remarkable people, landforms, birds and plants when he rowed ashore in 1769. For Parkinson, New Zealand was a place of miracles and wonder. Scientists are still marvelling at the uniqueness and strangeness of a country which can boast carnivorous snails, flightless birds such as the kiwi and kakapo and an alpine weta (*Hemideina maori*) which can be frozen solid then, when it thaws out, wander happily along its way.

When Sydney Parkinson drew his *View of an Arched Rock, on the Coast of New Zealand; with an Hippa, or Place of Retreat, on the Top of it* he not only recorded what his eyes were seeing but also what he was thinking and feeling at the time. You can imagine, when he drew this strange rock formation, he would

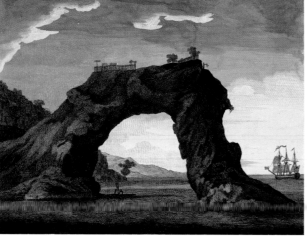

TOP: THE SUNDAY MORNING ANGEL (1948), an ink drawing on paper by Colin McCahon (1919–87).

BOTTOM: VIEW OF AN ARCHED ROCK, ON THE COAST OF NEW ZEALAND; WITH AN HIPPA, OR PLACE OF RETREAT, ON THE TOP OF IT (1773), a hand-coloured engraving by James Newton based on a drawing by Sydney Parkinson (circa 1745–71).

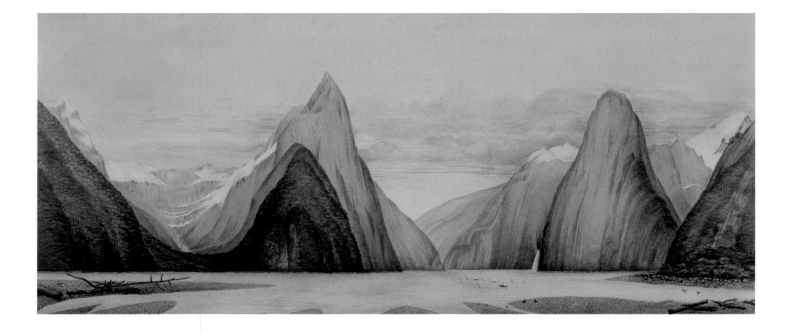

have been excited and relieved to be on dry land after months at sea. He probably made a few changes to what he saw: I suspect he shifted Captain Cook's sailing ship around so it fitted neatly into the right-hand segment of the composition. (He would have wanted to make sure the picture recorded the fact that Cook's ship had actually made it all the way here.)

The paintings of the first European artists – including Parkinson – are a mixture of seeing and imagining. A century later, John Buchanan's *Milford Sound, looking north-west from Freshwater Basin* presents New Zealand as a calm, orderly dream-world. Even the cliffs appear to be made of smooth stone, nicely toned and flowing into one another. Like other nineteenth-century artists, Buchanan painted the New Zealand landscape as though it were a solemn cathedral. In this watercolour, the lake is as smooth as a polished floor. The picture was intended to look grand and awe-inspiring, but it also had to fit inside Buchanan's backpack – hence its small size, around 20 by 50 centimetres. Many early depictions of New Zealand like this one were posted back to England to help convince other people they should move here.

To this day New Zealand artists remain travellers and adventurers, discoverers of new territories. There is a lot of travelling by land, sea and air to be found on these pages, as you will see. Colin McCahon wrote that 'the history of painting in New Zealand is very largely a record of painters' travels, their arrivals and departures . . .'. His *Sunday Morning Angel* suggests another, equally important kind of

MILFORD SOUND, LOOKING NORTH-WEST FROM FRESHWATER BASIN (1863), a watercolour on paper painting by John Buchanan (1819–98).

PEACEABLE KINGDOM (2002), an acrylic and oil on canvas painting by Tony de Lautour (born 1965). Lots of contemporary artists look to the past for inspiration – it's just that Tony de Lautour does it in a more direct way than most. Tony spends a lot of time in antique and junk shops, buying old paintings from both New Zealand and overseas. Some of them he tampers with, painting in a few things: in this painting he has added a snake, a finger-pointing cat and a kiwi toting a bottle of liquor. He has also changed the shape of the mountain and painted a table on the far shore. Is this such a peaceable kingdom after all? At the front of the picture, trees have been chopped down and, on the stump of one of them, an egg is cracking. Is this the Birth of the Nation? Or is something suspicious going on?

travel – between the realm of the imagination and the everyday world we live in.

'As in mountaineering so in art,' Frances Hodgkins once wrote. 'There is only a very narrow edge of safety on which we can walk.' Art is a balancing act involving what the eye sees, what the mind thinks and what the heart feels. It is about showing the world in new and original ways and – particularly in recent decades – taking risks.

As well as being a big adventure, a work of art can be a way of storing knowledge, ideas and images. Many New Zealand artists – among them Shane Cotton and W. F. Gordon (see page 55) – are also collectors, picking up things from the past and present and rearranging them, finding new combinations. According to the Oxford *Dictionary of New Zealand English*, there is a local word to describe this kind of salvaging and collecting: *poozling*. That is what Pat Hanly was doing when he collected symbols of life, wisdom and love in his 1983 painting *Wonder Full*.

WONDER FULL (1983), an acrylic and enamel on board painting by Pat Hanly (1932–2004).

Poozling and journeying are two of the big themes in the New Zealand art you will find in this book. Looking at works by famous or lesser known artists makes you realise that this country was built on the visions of its artists just as it was built on milk, cheese, wool and the All Black scrum. New Zealand is not just a country filled with people doing practical things. Sure, there is tree-felling, road-laying, house-building and the milking of cows (and you'll see a lot of them in this book), but throughout New Zealand's history there have been artists intent on using the world around them as a point of departure, from which they could take imaginative flight.

Painters working in New Zealand are more heroic than you might at first think. Art has always been a shaky way of making a living in this country. Even in the twenty-

DEATH OF A MOA (c. 1925), a watercolour painting by Trevor Lloyd (c. 1863–1937). The artist Rosalie Gascoigne wrote: 'We have squelch in New Zealand because it's green . . . you can walk in it, and it smells sweet.' There is certainly 'squelch' in Trevor Lloyd's *Death of a moa*.

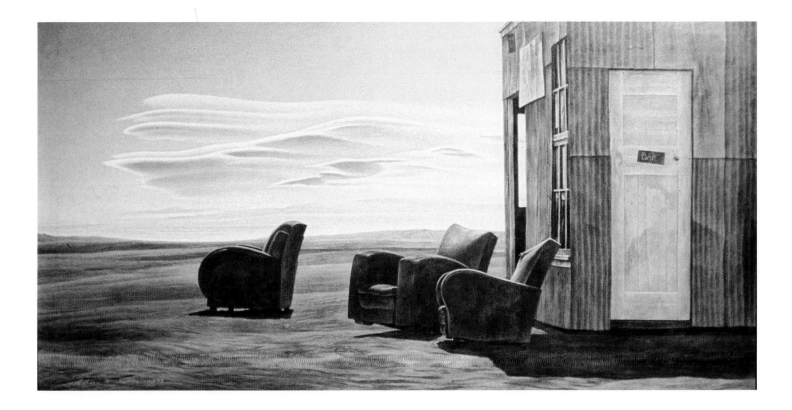

first century it is difficult as a painter to make enough money to live on. It requires courage and commitment, as well as imagination and skill. Many of the artists in this book had to paint in the evenings while holding down a 'real job' during the day: John Buchanan was an expert on New Zealand plants, the young Colin McCahon worked in orchards, Trevor Lloyd was a newspaper cartoonist, Toss Woollaston was a door-to-door salesman, carrying around a briefcase full of household products. Maryrose Crook sings in a rock band – as Phil Judd of Split Enz did a few years earlier.

In bringing together some of the country's images of itself – its people and its environment – *Back and Beyond* plots a history of the New Zealand imagination from prehistoric times to the twenty-first century. Here, we encounter some of the country's dreams and nightmares, diversions and digressions – there are even a few interludes of moa-spotting – as we accompany generations of artists on their journey through these shaky, remarkable islands.

DOGTRIALS BAR (1977), an egg tempera on gesso painting by Grahame Sydney (born 1948). Grahame Sydney's *Dogtrials Bar* has a few things to tell us about looking at art. The French painter Henri Matisse once said that a good painting should be like a good armchair. Maybe he was right – although I think, to be more precise, art should be like one of Grahame's rustic old armchairs pushed out into the open air. Here, the furniture almost has a life of its own. Meanwhile, in the sky above, the clouds are sending us all sorts of messages: the season might be changing, or maybe the hot Central Otago afternoon is ending? Looking at art is like sitting in one of these comfortable (yet slightly wayward) chairs. You're not in the tin shed any more. The world is coming at you – and wherever you are seated you are in the front row.

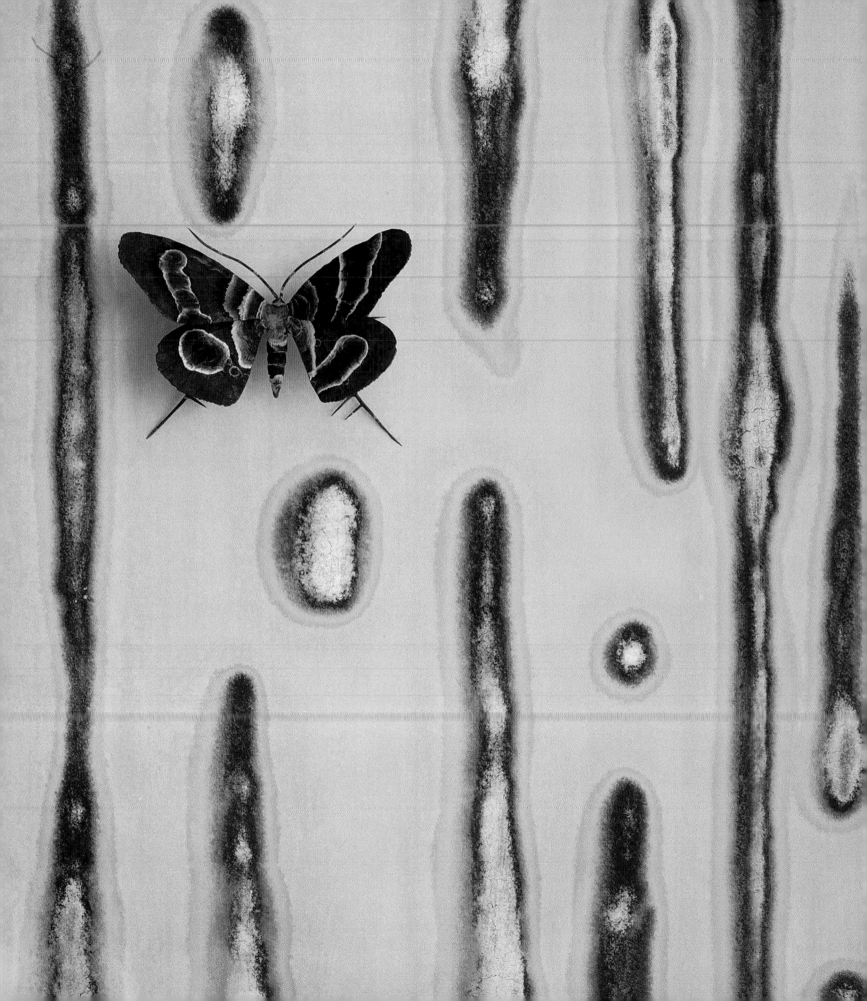

Way Back When

Some artists look back beyond human history to a time when there were no people on the planet. Others conjure up imaginary and real characters, and events from the distant past. By using their imaginations to travel as far back in time as they can, these artists offer us myths and wonders – some of which feel strangely familiar.

Detail from KOROMIKO (2003), a work made up of a bronze moth on a lime-washed, blowtorched fibro-cement panel by Elizabeth Thomson.

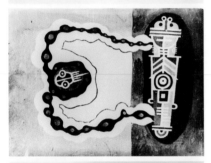

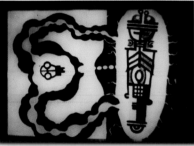

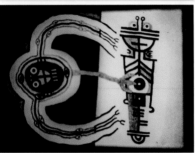

Of plants, planets and people

Len Lye's art goes a long way back – further than human history to the origins of life on the planet. The main characters in his painting *Fern People* are tiny, ancient life-forms which might one day evolve into plants or people. When Len was a boy, he lived at Cape Campbell – near the top of the South Island. 'I lived hard by the Great Flasher, a big white lighthouse about five hundred yards from our house,' he wrote. 'Wintertime, we saw whales. The house was just below the brow of a long camel-hump of grassy hill . . . On one side was an endless sandy beach studded with great hunks of rock that harboured big lobsters idling in the sun.'

Rather than paint the big things – the whales and lighthouses – Len wanted to paint the kinds of subjects you would see through a microscope or find in a rock pool. Art, for Len, was a laboratory for exploring patterns and shapes he observed in nature. He was also very interested in traditional Maori art and you will find koru/spiral patterns in this painting as well.

Len Lye left New Zealand aged 20, but his early influences stayed with him until his death. In the twenty-first century, his paintings, films and motorised sculptures still seem as if they belong in the future. His designs for large-scale sculptures are being built and installed around the country. In 2006 his *Water Whirler* was placed on Wellington's waterfront where it dances its watery dance nine times a day.

LEFT: SOME FRAMES FROM THE FILM TUSALAVA (1928), by Len Lye. Here Len invented a strange encounter between a spider-like being and a pod-shaped organism. His films capture the kind of energy he experienced as a child living for a time in the windy city of Wellington – a place where the sky is constantly on the move and things are always changing into other things.

OPPOSITE: FERN PEOPLE (1946), an oil painting on plywood by Len Lye (1901–80).

Earth, fire and water

Looking millions of years into the past, Alexis Hunter's *Creation* depicts the flaming surface of a volcanic planet. Afloat in a pond, the faces of newly hatched people appear. Is this a view of the creation of the world or might it be a science fiction fantasy?

Compared to *Creation*, Jane Pountney's *White Terraces* is warm and inviting – yet just as dreamlike and mysterious. Jane's painting is based on a place that actually existed: the White Terraces, which used to be a world-famous thermal wonder just outside Rotorua. Artists came from all around the world to paint the White Terraces and the nearby Pink Terraces. Until the terraces were destroyed by the eruption of Mount Tarawera in 1886, tourists and locals used to sit for hours in the pie-shaped craters, up to their necks in the warm, steaming water. In Jane's painting, the ponds of water are a stairway leading into the cloudy vapours beyond.

These large, vibrant, richly painted canvases by Alexis and Jane tell us a few things about the act of painting itself. It can be a very passionate and very energetic business indeed. These paintings don't paint themselves. They require a lot of effort, concentration and imagination. Painting is a physical process as well as a mental one.

WHITE TERRACES (1992), an oil on canvas painting by Jane Pountney (1949–2004). Jane Pountney was born in Rotorua, where, as a child, she heard many stories about the Pink and White Terraces.

CREATION (1987), an oil on canvas painting by Alexis Hunter (born 1948). Alexis Hunter grew up in Auckland and has been based in England since 1972. After establishing herself as a photographer, she spent the 1980s producing a dazzling series of paintings based on myths, many of which harked back to her childhood experience of the mudpools, volcanoes and bush of New Zealand.

Moa hunting

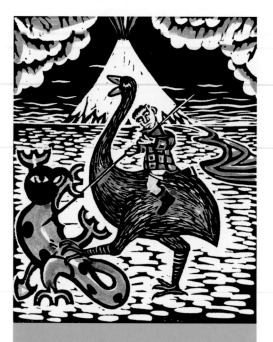

GEORGE (2004), a coloured woodcut by Harry Watson (born 1965). In Harry Watson's *George*, the knight, here a farmer wearing gumboots and a swanndri, is spearing a taniwha. The woodcut is a re-imagining of the myth of St George – the mythical founder of England and legendary killer of dragons – only here his trusty steed has been replaced with a moa.

A few years ago, not far from Timaru, I was taken by a farmer up a rocky hillside to inspect a small cave which had once been used by moa-hunting Maori as a hideout. The cave was above a dead-end gully that was a perfect natural moa trap. Since people started digging around for such things, countless moa bones have been found in that area. Archaeologists also found many drawings (like those on the right) made by moa hunters on the walls of caves.

I imagine the Maori in the caves made the drawings to while away the hours as they waited in silence for other members of the tribe to herd the moa towards the gully. Maybe the hunters thought that by drawing the moa they were casting a spell over the live moa and ensuring a good catch? On the other hand, they might have been remembering the great days of the past when there were many more moa. They had to make the drawings from memory or imagination – or a mixture of both. Since the time of those early cave images, artists in this country have been doing a lot of remembering and a lot of imagining.

While moa have long been extinct in the 'real' world, they have continued to breed in the imaginations of artists. Not only do painters continue to paint them (you'll find an impressive population on these pages), but there are still reported sightings in the South Island just about every summer. And not all these sightings are by motel owners in out-of-the-way areas trying to drum up trade during the quiet season.

MAORI ROCK DRAWING (date unknown) at Craigmore, Pareora, in South Canterbury, as copied in 1946 by Theo Schoon (1915–85).

A magical wooden head

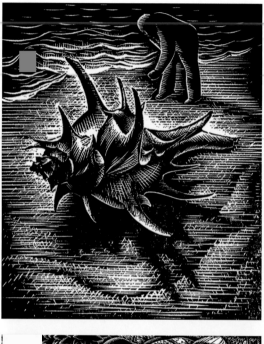

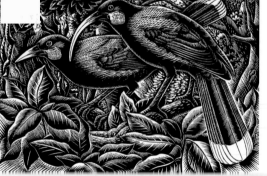

As the Maori legend goes, in a pa beside the Manukau Harbour there was once a magical carved head which killed anyone who looked at it. This story was the basis for E. Mervyn Taylor's wood engraving, *The Magical Wooden Head* (on right). Here a bad-natured wooden head is battling it out with a tohunga – which is the Maori word for a wise man or spiritual leader. All the forces of the universe swirl around the two adversaries. Stars, clouds and planets are caught up in the deadly combat. In the lower half of the image you can see the outlines of bodies, bones and skulls of earlier victims. In Mervyn Taylor's version of the Big Fight, the tongue of the wooden head unfurls and wraps itself around the tohunga's leg. Things are looking grim for him. Yet, according to legend, after one heck of a battle, the tohunga won.

E. Mervyn Taylor was also an observer of the natural world and is best known for his images of birds (including the now extinct huia – on left). Mervyn Taylor worked for years at the *School Journal* and many of his greatest images were published there during the 1940s.

TOP: SPINY MUREX (1944); BOTTOM: NGA HUIA (HUIAS) (1949); OPPOSITE: THE MAGICAL WOODEN HEAD (1952), wood engravings by E. Mervyn Taylor (1906–64). In these three wood engravings, the white lines were cut into wood with a sharp implement – then the surface of the wood was inked and printed on to a sheet of paper. Wood engraving is not unlike the traditional Maori art of moko, where small chisels were used to tattoo the face or body.

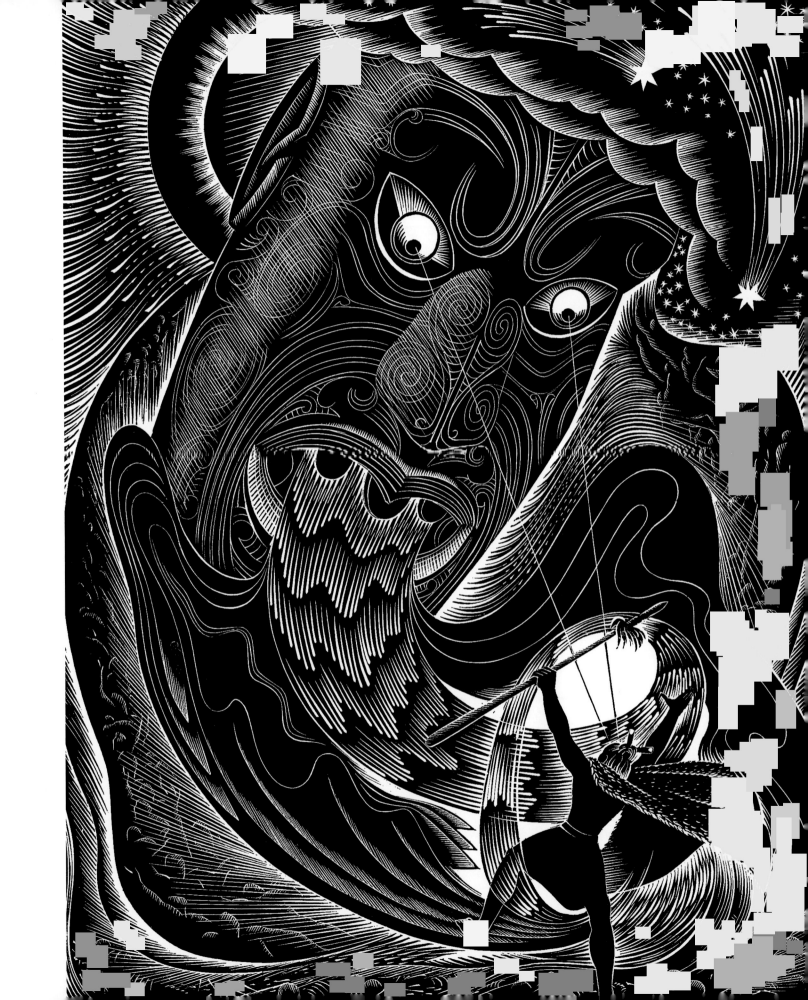

Hine-titama

The woman figure at the centre of the painting is Hine-titama, the mother of humankind. She is a mixture of the godly and the earthly – and was, according to legend, the first human being. The painting is from a series of pictures by Robyn Kahukiwa entitled 'Wahine Toa', which means 'women of strength'. Robyn's paintings celebrate the power and resilience of women characters in Maori myths, while acknowledging those same qualities in Maori women in the modern world.

Robyn's painting of Hine-titama contains other characters and stories. The lizard is Maui (the shape-shifter and fugitive who will reappear in Tony Fomison's *The Fugitive* on page 27); the male figure is Tane, who is the father of Hine-titama's children. The unborn child which floats on the left of the painting represents their children. Robyn Kahukiwa goes a long way back into Maori legends and history to uncover stories and characters that live on today.

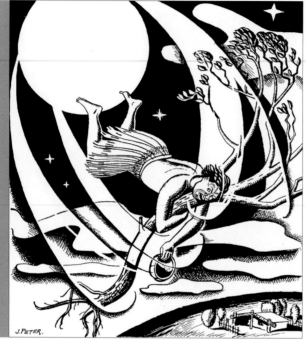

RONA AND THE MOON (1946), a drawing for the *School Journal* by Juliet Peter (born 1915). Since Maori myths were first published in books, illustrators have interpreted them. Here we see Rona, who insulted the moon, Te Marama, being pulled up into the sky. Juliet Peter made this drawing for the cover of the *School Journal* in 1946. Juliet is an important artist who produced hundreds of drawings for the *Journal* during the 1940s and 1950s. She has also been a potter, painter and printmaker.

HINE-TITAMA (1980), an oil on board painting by Robyn Kahukiwa (born 1940, Ngati Porou, Te Aitanga a Hauiti, Ngati Konohi, Te Whanau a Ruataupare). Robyn Kahukiwa was born in Sydney, Australia. She moved to New Zealand aged nineteen, and worked as a graphic artist. One of New Zealand's most celebrated and important artists, Robyn recently shifted from Rotorua to Auckland.

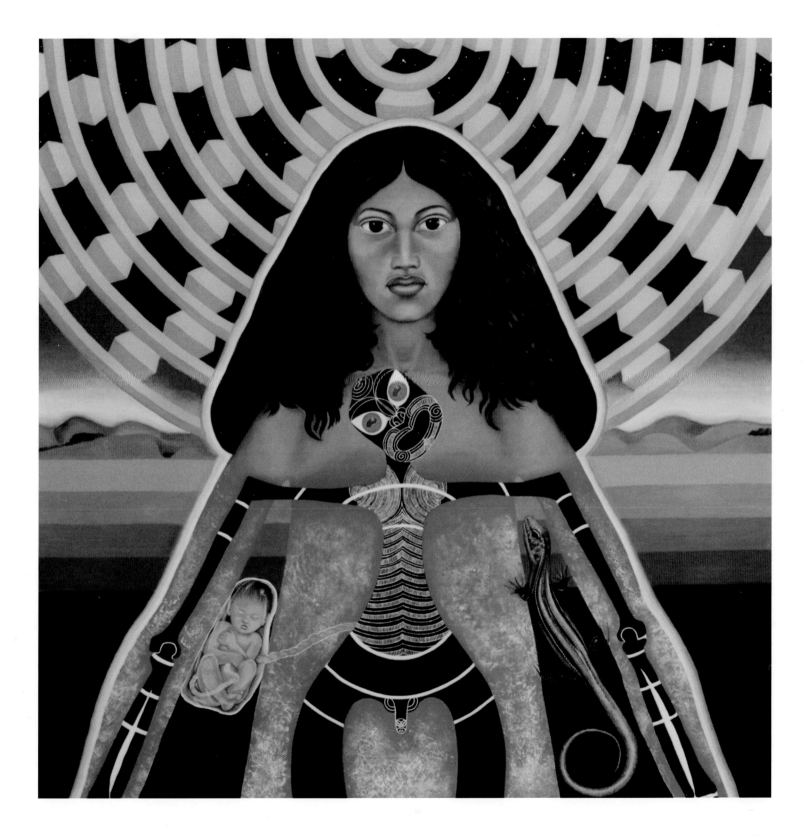

A fugitive and a defender of forests

Stories and poems about New Zealand have often featured isolated figures, usually striding off into the bush or high country. There have been a lot of paintings of lone men in New Zealand art. The solitary figure in Tony Fomison's painting *The Fugitive* is Maui

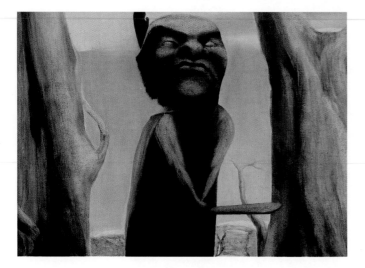

– the 'shape-shifter' – who, according to legend, challenged the goddess Hine Nui Te Po and was crushed between her thighs. It is a chilling painting about life and death. Tony painted Maui looking like a sprite or an elf. Maui is naked and has nothing with which to defend himself apart from his instincts, his cleverness and some quick footwork. The land looms above him; the roots of trees are like the claws of birds grasping the earth.

Another lone figure dominates *Nga Toki Mate Whenua*, only in this case the central man is armed and possibly dangerous. The title of the painting means 'Many adzes for chopping down trees will mean death to the land'. The figure is most likely a guardian of the forest. He is waving his greenstone club or mere to ward off intruders or anyone who might exploit the natural world. Tony Fomison often drew upon Maori and Pacific mythology in his work, although he was also inspired by Northern European art, horror movies and fantasy.

As a young man, Tony Fomison spent a lot of time investigating the Maori cave paintings around Canterbury. These influenced him later when he was painting such mythical pictures as *The Fugitive*. The long, sinuous limbs of the fugitive are like those of the figures in the ancient rock art Tony saw.

ABOVE: NGA TOKI MATE WHENUA (1983), an oil on hessian painting by Tony Fomison (1939–90).

OPPOSITE: THE FUGITIVE (1981–83), an oil on hessian over board painting by Tony Fomison.

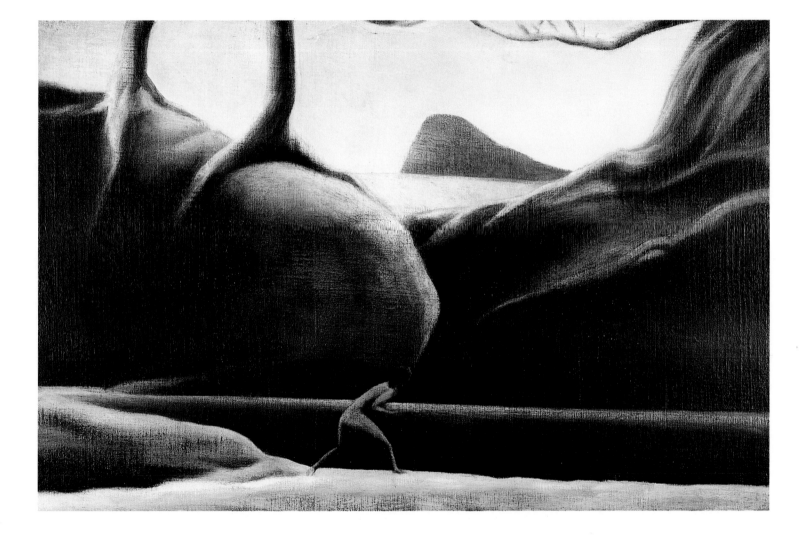

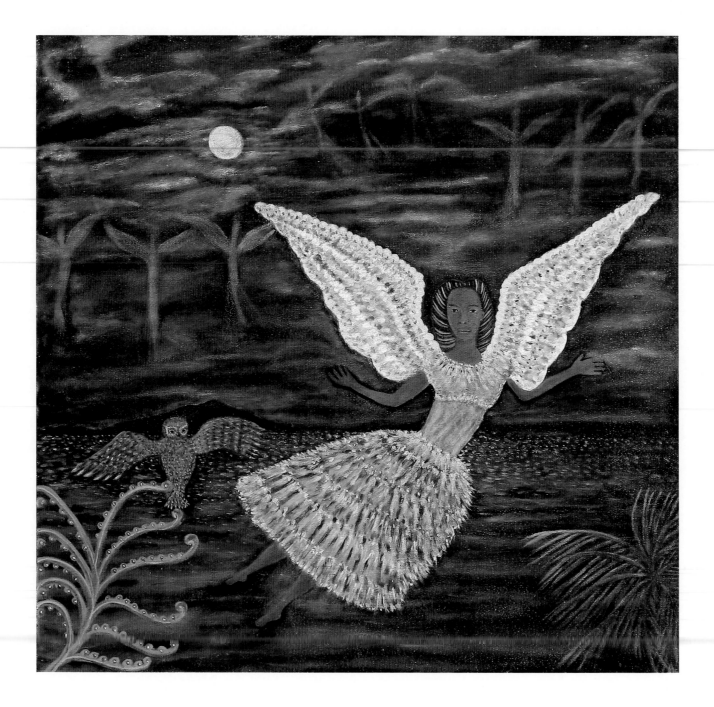

Moon and moth

The moonlit figure in Hariata Ropata Tangahoe's *Purere hua (Moth lady)* might have come from a Maori legend, but she is also from the artist's dream-life. As she floats across the surface of the painting, her feathers glow and the shape of her wings is echoed in the sky beyond, where nine other moths are flying in formation above the sparkling sea. In Maori tradition, the owl usually symbolises wisdom – and there is certainly something owl-like and wise about Hariata's 'moth lady'.

Like her cousin Robyn Kahukiwa, Hariata paints mythological woman figures who are, in many ways, versions of herself. In *Self portrait* (on right), Hariata stares out at the viewer from behind a vase filled with flowers. There is no fancy paintwork – just bright, flat areas of colour that hit you in the eye. Curtains on either side of the painting part to reveal a splendid pink paddock with four black horses. Painters like Hariata don't want to explain the world – they just want to present as many mysteries and marvellous things as possible.

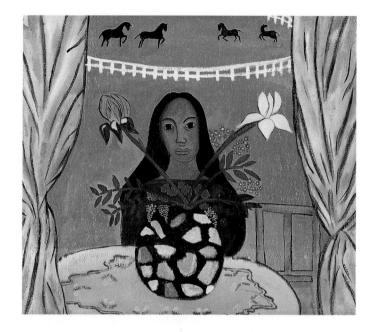

OPPOSITE: PURERE HUA (MOTH LADY) (2004), an acrylic on canvas painting by Hariata Ropata Tangahoe.

ABOVE: SELF PORTRAIT (1982), an oil on hessian on hardboard painting by Hariata Ropata Tangahoe.
Born in Otaki in 1952, Hariata Ropata Tangahoe began painting in the 1970s, encouraged by Tony Fomison, Colin McCahon and other artists. She has exhibited her stone sculptures and paintings widely. She has tribal affiliations with Ngati Toa, Ngati Raukawa and Te Atiawa.

One at a time, please

John Walsh's family comes from Tolaga Bay, near Gisborne, so it's hardly surprising that he is both a keen fisherman and a bit of a surfer. In his paintings, open water is seldom far away. He works in a studio overlooking Lyall Bay, on the south coast of Wellington. John often paints lone figures standing near water.

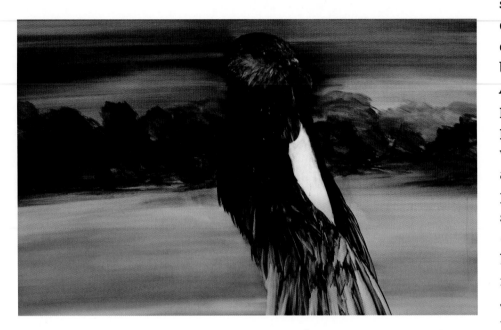

Artist on the foreshore is a kind of self-portrait as a native bird – a kakapo, perhaps. The bird is wearing the sort of white t-shirt that you often see male artists wearing in photographs. Some painters like to think of themselves as serious, muscular no-nonsense guys (and, like kakapo, pride themselves on being solitary, nocturnal and usually not all that involved in domestic life). John isn't like that. His studio is in the basement of the family home – and a bustling family life is always coming at him, down the stairwell. Usually there are surfboards and a boat or two in front of the house. With his sons, John has often been spotted surfing the Lyall Bay break or catching fish in Cook Strait.

ARTIST ON THE FORESHORE (2004), an oil on board painting by John Walsh.

John Walsh's paintings use Maori legends as a starting point but his paintbrush keeps leading him off in other directions. In *One at a time, please* (on right), a man is staring into a tree of faces. Maybe the faces in the tree are all trying to question the figure at the same time – and he is saying 'One at a time, please' because they are drowning each other out? Are the tree-faces real people, friendly spirits – or maybe they are up to no good? Often the characters in John's paintings seem to be going back to the land or ocean to acquire some kind of wisdom.

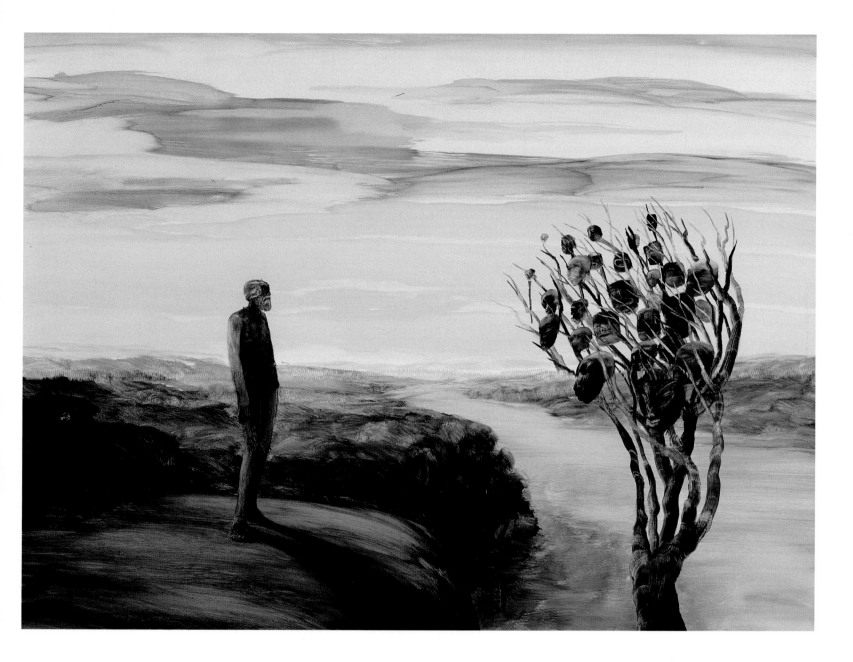

ONE AT A TIME, PLEASE (2005), an oil on board painting by John Walsh
(born 1954, of Te Aitanga a Hauiti and Irish descent).

A giant relaxes

Giants often crop up in the myths and stories of cultures all over the world. When I first saw Euan Macleod's painting *Spa*, I was reminded of the Irish mythical figure Finn MacCool. It is as if he has walked all the way from the northern hemisphere to New Zealand, then collapsed, cold and exhausted, in the crater lake of a volcano just off the North Island coast. The volcano looks very like White Island (Whakaari), not far from Whakatane. The giant has come a long way and he deserves a good rest.

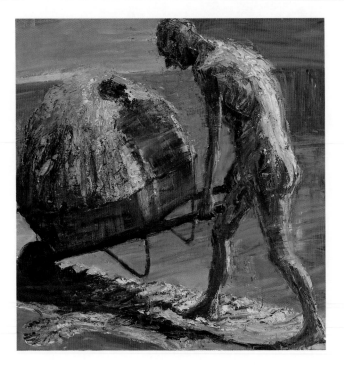

Although Euan has lived in Sydney, Australia, for over 20 years, he keeps returning to New Zealand in his paintings. He has also painted a giant figure reclining in inlets around Banks Peninsula, where he grew up. At other times, the huge figure is pushing a wheelbarrow filled with soil along a narrow strip of land (on left). If you look closely at the bottom of this picture, you'll see that the giant is pushing his wheelbarrow down the South Island. Those tiny crinkles in the ground are the Southern Alps – and that is Banks Peninsula, near Christchurch, in the bottom left-hand corner.

My friend Geraldine (aged 12), who is good at figuring out paintings, reckons the giant in the painting is actually Euan Macleod himself. In the paintings he is returning to the places where he grew up – only now that he is an adult he has outgrown these places and he can never fit in again.

ABOVE: BARROW MAN (2007), an oil on canvas painting by Euan Macleod.

OPPOSITE: SPA (2005), an oil on canvas painting by Euan Macleod (born 1956).

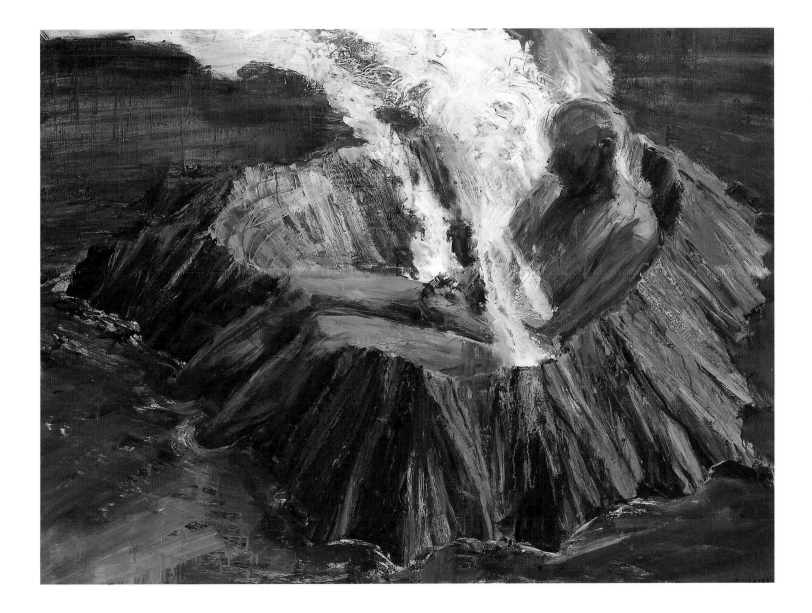

Headlands

Manukau Heads is not that far from the Auckland suburb of Titirangi, where artist Elizabeth Thomson grew up. It is a wild, rocky headland – the point where the Manukau Harbour meets the Tasman Sea (and also where the battle with the magical wooden head – on page 23 – took place). In *Manukau Heads* (on right), Liz Thomson presents us with another kind of 'head' land – one that has eyes and ears.

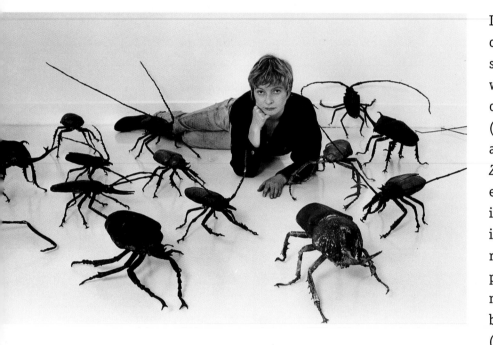

In Liz's art, cliffs, rocks, walls and ceilings come to life. As well as making prints, she produces bronze insect sculptures which she has exhibited both inside and outside art galleries around New Zealand (see photograph on left – which first appeared on the front page of the *New Zealand Herald*). Since she was a young girl exploring the bush around the family home in Koromiko Road, Titirangi, Liz has been intrigued by the weirder side of nature. She remembers watching and listening to huge puriri moths flying around her bedroom at night, crashing into the light fittings and bumping into the window. In *Koromiko* (on page 14) one of her bronze moths has landed on a painted background; the title of the work refers to the name of the street she grew up in.

ABOVE: Photograph of Liz Thomson and metal insects, 1990, courtesy of the *New Zealand Herald*.
When she was a schoolgirl, Liz Thomson was sent, as an exchange student, to New Caledonia in the Pacific. She remembers being terrified by the huge bugs that she encountered there. Twenty years later, her memories of those insects were transformed into these bronze monsters.

OPPOSITE: MANUKAU HEADS (1987), a photo-etching by Elizabeth Thomson (born 1955).

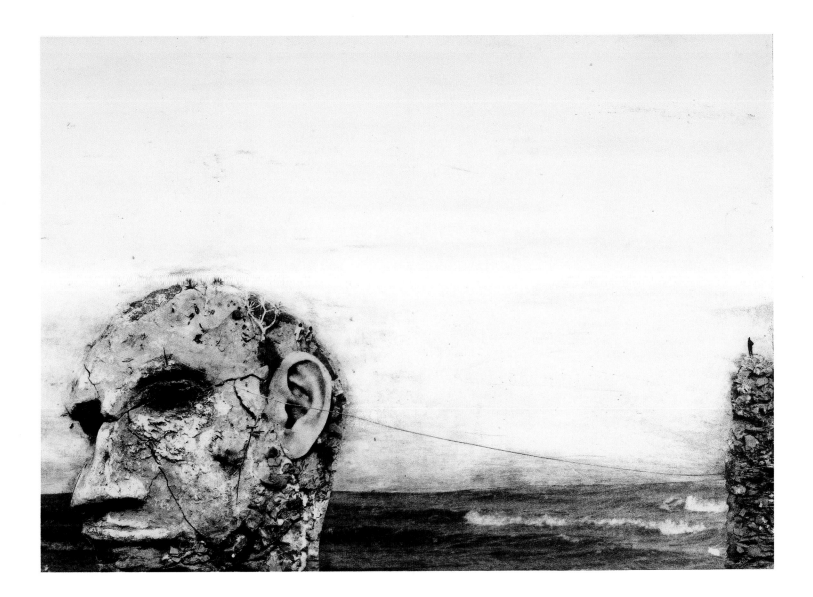

The national bird of the New Zealand imagination

In the nineteenth century, moa appeared in many book illustrations, cartoons and works of art. Although it had long been extinct, the moa was probably as famous as the kiwi – at least until early in the twentieth century. It was only then that the kiwi finally became the National Bird of New Zealand.

The artist Trevor Lloyd, who painted *Death of a moa* in 1925 (see page 12), didn't help the moa's chances of becoming the official national bird. Trevor Lloyd published many drawings of kiwi in newspapers between 1904 and 1937 – and art historian Roger Blackley has written that these images 'were largely responsible for securing this bird as an acceptable national emblem'.

In 1970 Ted Bullmore painted a moahunting scene for the Rotorua Museum to accompany an exhibit of real moa bones and a stuffed specimen of the bird itself. In Ted's painting, one spear has already hit the nearest bird and the other hunter is about to strike. In one hand he holds the end of a flax rope which is attached to his spear as though it were a harpoon. With its dreamy clouds and sunny, swampy setting, the painting could be a scene from a jolly Boy's Own adventure. Not so jolly if you're a moa, though.

Although moa have not been seen for centuries, they keep reappearing in the nation's art (a bit like the Pink and White Terraces – see page 18). The paintings by Trevor Lloyd and Ted Bullmore suggest to me that we should officially declare the moa the National Bird of the New Zealand Imagination.

MOAHUNTERS (1970), an oil on board painting by Edward (Ted) Bullmore (1933–78).

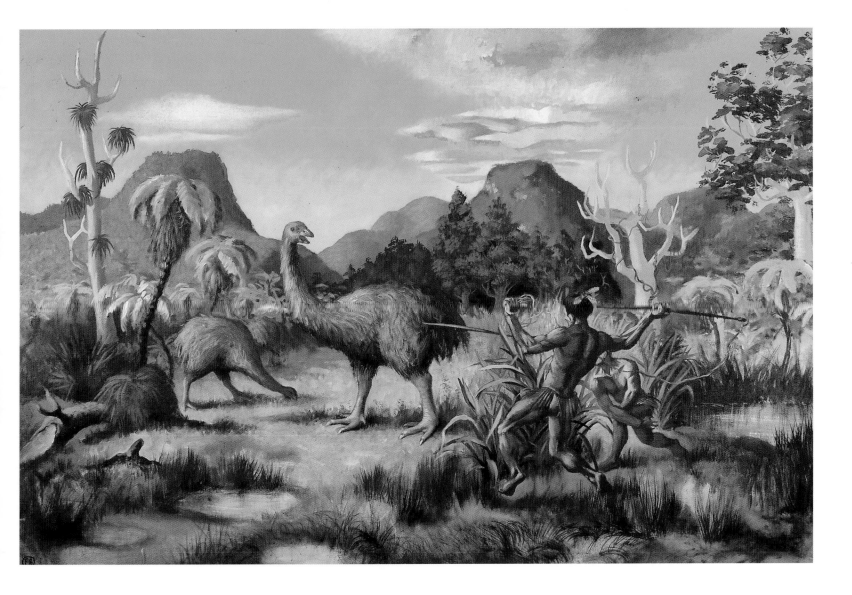

The real kiwi

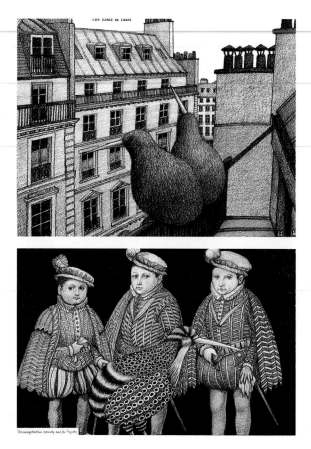

Graham Percy's drawing (on right) is a retelling of the myth of the Trojan Horse – only instead of installing a band of soldiers inside a wooden horse, he has planted a flock of kiwi atop a punga-legged, pretend moa. Why are they trying to get inside the fortress of the wild pigs? This does not sound like a very good idea. Maybe they think their smart woollen outfits will protect them?

In Graham's recent drawings, he envisages a New Zealand which is inhabited by millions of kiwi – and in which the human beings have become the endangered species. Since the 1960s Graham has lived in England. Maybe it is because of homesickness that he is so fascinated by kiwi (and the occasional moa). His drawings teem with these curious, inventive but slightly misguided creatures. Maybe his birds – frequently portrayed on tiki tours of Europe, past and present – are best thought of as stand-ins for human 'Kiwis' – awkward and flightless, but with a fine sense of humour and capable of travelling through time and space.

ABOVE, TOP TO BOTTOM: THE KIWIS IN PARIS and THE VARIEGATED KIWI SPECIALLY BRED FOR ROYALTY (2004), two ink drawings by Graham Percy. In the 1960s, Graham Percy (born in Stratford, Taranaki) went to Elam School of Fine Arts, Auckland, where his teachers included Robert Ellis and Michael Nicholson. In London, he graduated in graphic design from the Royal College of Art in 1967. He still lives in England and has illustrated over 100 books for children and adults.

OPPOSITE: TO GET INTO WHERE THE WILD PIGS LIVE, THE KIWIS HAVE MADE A GIANT MOA – JUST LIKE THE WOODEN HORSE OF TROY (2005), an ink and acrylic drawing on paper by Graham Percy (born 1938).

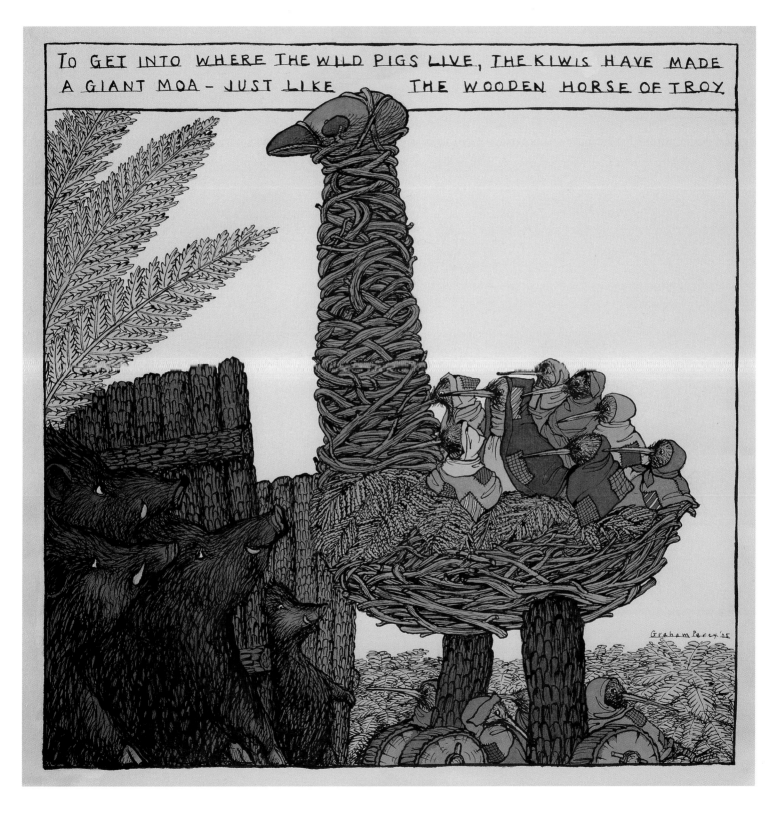

TO GET INTO WHERE THE WILD PIGS LIVE, THE KIWIS HAVE MADE A GIANT MOA – JUST LIKE THE WOODEN HORSE OF TROY

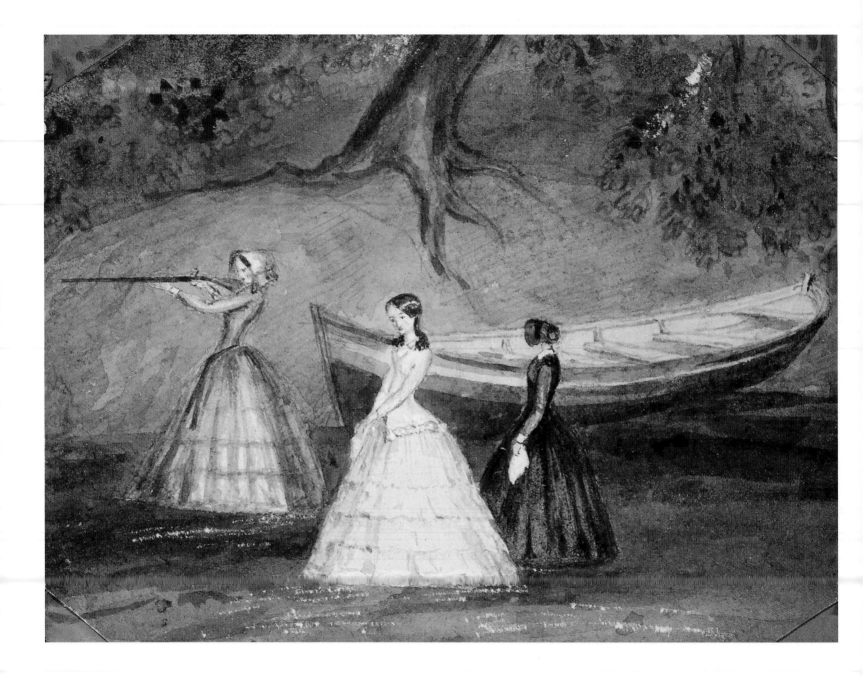

Dreams and Discoveries

Art is a process of discovery – which might explain why the periods when Maori and later European people 'discovered' New Zealand continue to fascinate contemporary artists just as they did painters of earlier times. These pictures tell a story of how New Zealand was shaped by dreams and imagination, as well as by practical thinking and hard slog.

SHOOTING PARTY, MANSION HOUSE, KAWAU ISLAND (1853),
a watercolour by Charles Heaphy (1820–81).

Whales and waka

DAWN TO DUSK (AFTER HODGES) (1994), an oil on board painting by Nigel Brown (born 1949). Like Tony de Lautour (on page 10), Nigel Brown won't leave history alone. This image is based on a well-known painting by William Hodges, *Cascade Cove, Dusky Sound* (1773). Hodges accompanied Captain Cook on his voyages and would frequently go ashore in search of subjects to paint. In this painting, Nigel Brown has based his Maori figures and waterfall on Hodges's painting, but he has added the seated figure of Captain Cook, who is looking up, like a younger brother, at the Maori chief. In real life, the sea captain might not have been so humble and attentive in his dealings with the tangata whenua.

Until roads and railroads were established in New Zealand late in the nineteenth century, boats were the main mode of long-distance transport. The coast of New Zealand was busy with steamships, sailboats and waka. As well all the arrivals and departures, there was also a lot of fishing, sealing and whaling going on.

While Joel Samuel Polack may well have been on whaling expeditions, for most of the time he lived in New Zealand during the 1830s he was a flax trader and storekeeper in the Northland settlement of Russell. In the nautical scene on the right, there are at least nine whales – and five boatloads of whalers are busy harpooning them. This was at a time when the ocean was filled with whales – and the north of New Zealand was the centre for whaling in the South Pacific. These days, whales are mostly protected (if they weren't they would have long ago suffered the same fate as the moa).

Joel Samuel Polack's picture was reproduced in a book which was published in England in 1838, *New Zealand; Being a Narrative of Travels and Adventures* . . . It is probably the kind of book that would have lured adventurous young men out to New Zealand from England with promises of fresh air, danger, excitement and the kind of job you could write home about. (Incidentally, Polack's book is believed to be the first book published that mentions the existence of a giant, flightless bird, long extinct at the time – the moa.)

THE NORTH CAPE, NEW ZEALAND, AND SPERM WHALE FISHERY (1838), engraving by Joel Samuel Polack (1807–82).

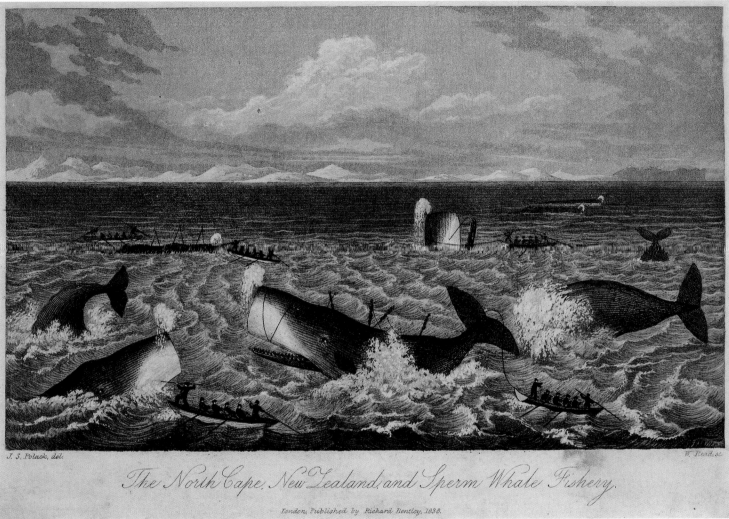

J. S. Polack, del.

W. Read, sc.

The North Cape, New Zealand, and Sperm Whale Fishery.

London, Published by Richard Bentley, 1838.

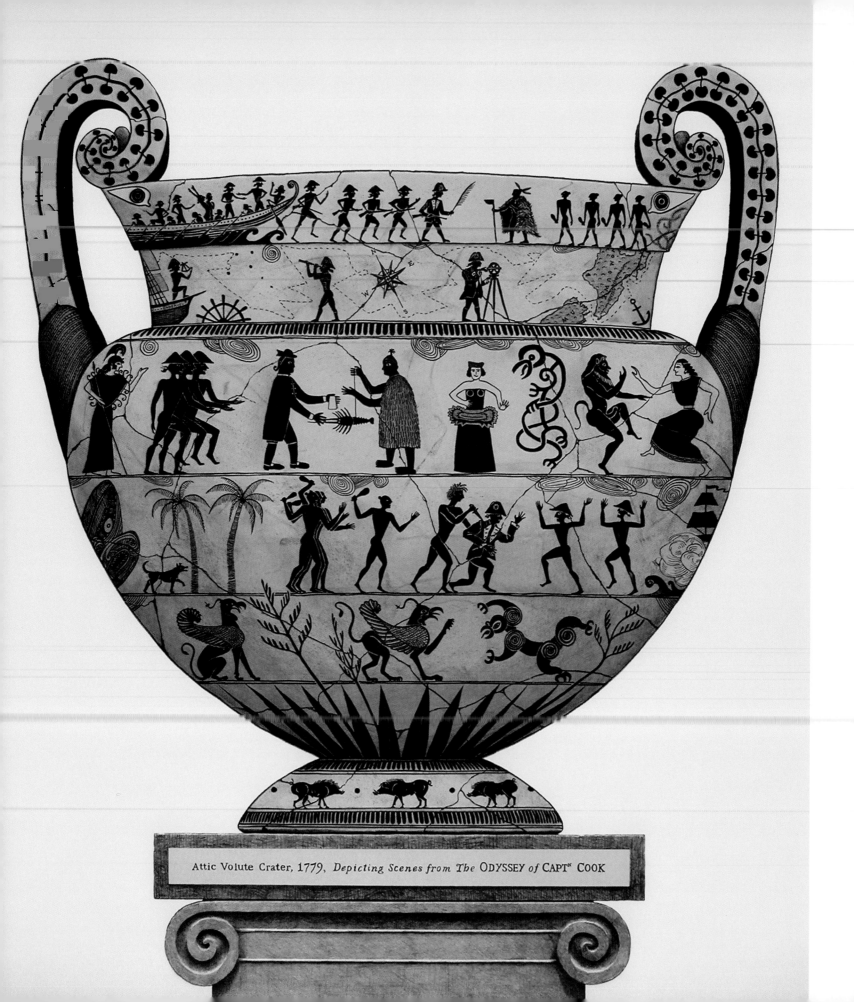

Attic Volute Crater, 1779, *Depicting Scenes from* The ODYSSEY *of* CAPT. COOK

Voyages around an urn

Printmaker Marian Maguire travels back into New Zealand history while, at the same time, exploring Greek myths. If you look closely at the figures around her lithographic print of an urn (on left), you will not only find Captain Cook and his crew, you'll see mythical Maori bird-men known as manaia and carved tiki figures – as well as some characters from Ancient Greek mythology.

Marian is inspired equally by traditional Maori art, by tales of South Pacific explorers and by the voyages of Odysseus (also known as Ulysses), who was the Greek king best known for his huge adventures during the ten years it took him to get home after the end of the Trojan war. (Way back in the seventh century BC, Homer wrote about that voyage in his epic poem *The Odyssey*.)

By mixing up stories, maybe Marian is saying that different cultures and traditions have a lot in common. In *Mount Egmont from the Southward* (above), she places an Ancient Greek warrior alongside a Maori chief. Behind them is Mount Taranaki (Marian has based her version on a famous painting by Charles Heaphy). The two characters are discussing things, playing a game or maybe they are plotting a future voyage together.

OPPOSITE: ATTIC VOLUTE CRATER, 1779, DEPICTING SCENES FROM THE ODYSSEY OF CAPTAIN COOK (2005), a lithograph by Marian Maguire (born 1962).

ABOVE: MOUNT EGMONT FROM THE SOUTHWARD (2004), a lithograph by Marian Maguire.
Marian Maguire runs the printmaking studio Papergraphica in Christchurch. As well as printing images by artists such as Ralph Hotere, John Pule, Gretchen Albrecht and Bill Hammond, she has produced suites of her own images.

South Seas fantasies

MINISTERE DE LA MARINE, ADMIRALTY-OFFICE (1865), an etching by Charles Meryon (1821–68). Born in Paris, Charles Meryon served in the French navy between 1842 and 1846, during which time he visited New Zealand and lived at Akaroa, near Christchurch. As well as making numerous drawings while there, he constructed a plaster model of a whale which had been caught in the bay. Many years after he had returned to France, Charles Meryon made an engraving of a government building in Paris, above which he depicted a sky filled with whales, outrigger canoes and South Seas islanders. His memories of the Pacific had come back to haunt him. In another engraving, he portrayed the waters of the Pacific flooding the streets of Paris, bringing with them sailboats and many denizens of the deep.

No one knows who painted *Maori in a canoe off shore near New Plymouth* or what is exactly going on here. An island which looks like an iceberg floats by; sealers are busy at work at the water's edge and, in the distance, Mount Taranaki looks like the base of a huge tree.

English and French artists in New Zealand during the first half of the nineteenth century often had trouble seeing exactly what was there. This painting is remarkable for its exaggerations and mistakes rather than for its accuracy. Perhaps the artist's imagination was running away with him. The 'Maori' figure in the foreground looks nothing at all like a Maori, wears an unlikely assortment of clothing and his canoe is certainly not a waka.

It is likely the painter based the picture on sketches made in other countries as well as in New Zealand. Like a figure in a Shakespeare play, the central character appears furious and maybe a little confused as to where he has ended up. His paddle is about to fall into the water. Perhaps he is angry at what is happening on the mainland and is cursing the men on the shore.

MAORI IN A CANOE OFF SHORE NEAR NEW PLYMOUTH (1840s), an oil on canvas painting by an unknown artist.

Between the bush and the town

New Zealanders pride themselves on their ability to chop down trees, make roads, bake scones, plough the back paddock . . . In the early days you had to be very practical and versatile to survive in this country. Charles Heaphy's painting of kauri-milling in Northland captures the toil of the early years. It also sums up how it was that so many majestic kauri trees were turned into planks of wood. One of the workmen – or 'sawyers', as they were called – has draped his jacket over the wooden planks. These are probably the kind of people Tony Fomison's protector of forests (see page 26) wanted to keep out. In Heaphy's painting it is the year 1839, and we are saying goodbye to native bush and hello to towns and buildings.

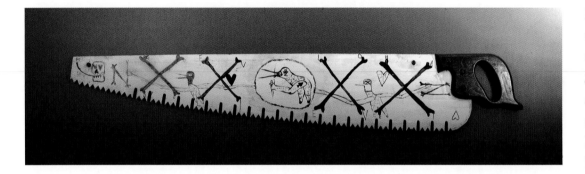

Painted a century and a half later, Tony de Lautour's *Settling Scores* (left) also has something to say about land clearance. It features crossed bones (some of which spell out 'NZ') and a cartoon-like kiwi with an arm tattoo and a knife in one hand. It asks: what sort of people are 'Kiwis'? The title makes me think that the artist is possibly commenting on the ruggedness and tough attitudes of the early settlers in New Zealand. Maybe the ferocious kiwi has a score to settle. Does he want revenge for all the harm tree-felling has done to his native habitat?

ABOVE: SETTLING SCORES (1995), an acrylic painting on a saw by Tony de Lautour (born 1965).

OPPOSITE: KAURI FOREST, WAIROA RIVER, KAIPARA (1839), a watercolour painting by Charles Heaphy (1820–81). The only soldier in the New Zealand armed forces to win the Victoria Cross in the New Zealand Wars, Charles Heaphy was also an accomplished painter, adventurer, explorer and map-maker.

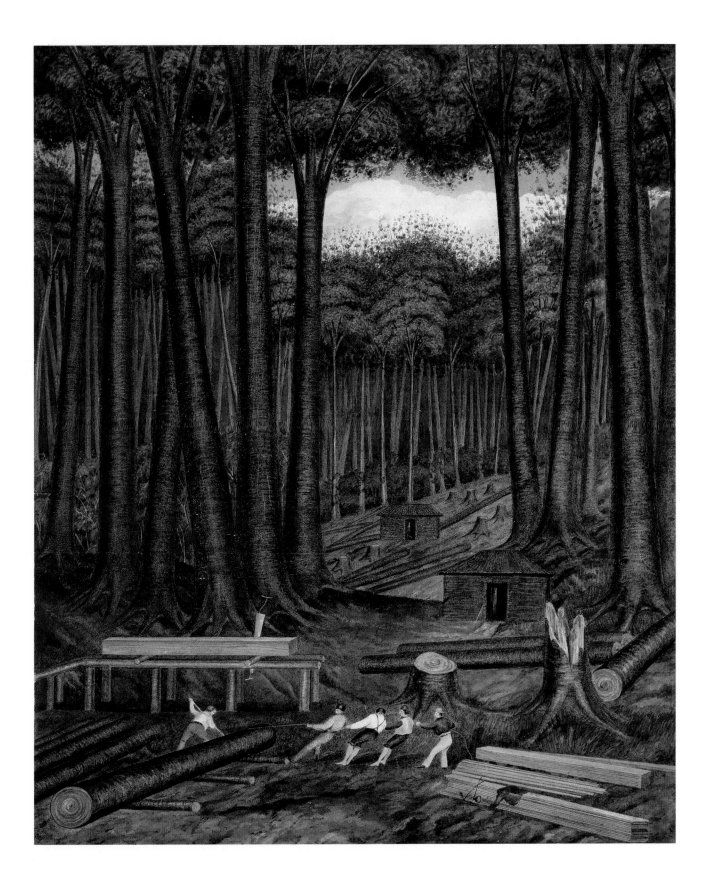

Unreliable quills and reliable paintbrushes

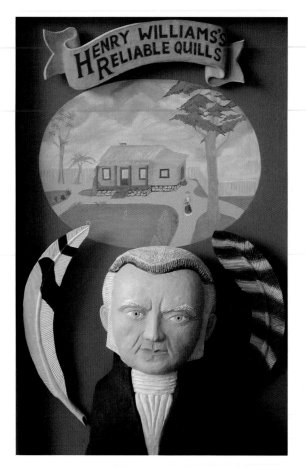

Harry Watson says history is 'about where we are standing at any one time, the land we are on, what happened there before'. In the work on the left he has carved and painted a head and shoulders of Henry Williams – the man who, back in 1840, translated the Treaty of Waitangi from English into Maori. Intentionally or not, Williams changed some of the meanings along the way. The result was that, in some instances, Maori did not understand that they were signing away their authority to rule the land. Harry's painted sculpture draws attention to the fact that Henry Williams's feathery writing quills were not as reliable or truthful as they should have been.

The feather on the right is that of a native falcon – representing Maori culture – while the other feather is from a magpie and symbolises the recently arrived Pakeha. The painted scene in the background is based on a watercolour of the Paihia mission house where Henry Williams lived and which he is said to have painted himself. Maybe Henry Williams was better with the brush than with the feathery quill.

Megan Campbell is a magpie when it comes to painting scenes from history. She picks up – or *poozles* – things from all over the place. *A Romantic View* borrows a number of characters from books and the history of art. On the right, the man looking into the lake is based on a figure in a well-known nineteenth-century painting, Caspar David Friedrich's *Wanderer Above the Sea of Fog*. The woman with brush and easel – on the left – is based on the pioneering New Zealand woman painter Dorothy Kate Richmond (1861–1935). The woman with gun is based on a watercolour by Charles Heaphy (you'll find that painting on page 40). Meg has painted these figures in oil paint on lino tiles left over from her kitchen floor – you can still see the pattern on the tiles underneath the paint.

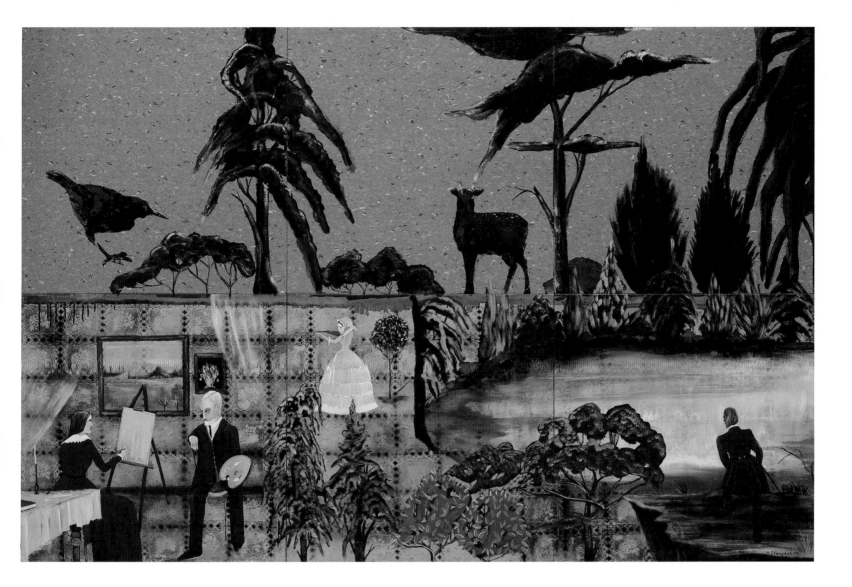

OPPOSITE: HENRY WILLIAMS'S RELIABLE QUILLS (2004), a painted wood construction by Harry Watson (born 1965).

ABOVE: A ROMANTIC VIEW (2005), an oil and bitumen painting on lino tiles, by Megan Campbell (born 1956).

Something not very comfortable to slip into

If you think this is just a pretty dress then you haven't looked hard enough. While the painting, at first glance, resembles a display in a frock-shop window, if you look around the bottom of the dress, there are three animals that farmers don't want around: a rabbit,

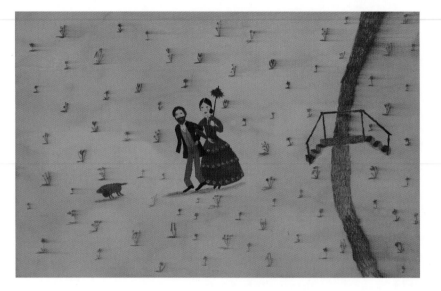

a possum and a weasel. Above them, the dress is decorated with noxious weeds – thistles and gorse – plants that are always threatening to take over farmland. At the top of the dress is a heart-shape in which a blue bird is trapped behind nettles or prickles. Two goldfish swim in the space between. You would get interesting comments if you wore this outfit into town.

Saskia Leek's painting (on left) is a study for a larger work – the two scuttling figures here were later incorporated into a painting she made of an 1860s group picnic in Woodhaugh Gardens, Dunedin. Maybe the lady and gentleman in Saskia's painting are hurrying to get to the picnic before the food runs out or their friends disappear. They are crossing a field of neatly spaced plants (look at Leo Bensemann's flowers on page 75 for some very similar plant life).

ABOVE: UNTITLED (STUDY FOR PICNIC AT WOODHAUGH) (2004), an acrylic and pencil on wood painting by Saskia Leek (born 1970).

OPPOSITE: THE SORROWFUL EYE: PEST DRESS (2004), an oil on canvas painting by Maryrose Crook (born 1957). Maryrose Crook lives in Dunedin. She was a musician long before she started painting and she still plays regularly in her band, The Renderers. Looking at old family slides inspired her to make paintings – all those mysteries and secrets stashed away in the family closet. She needed to do something about that.

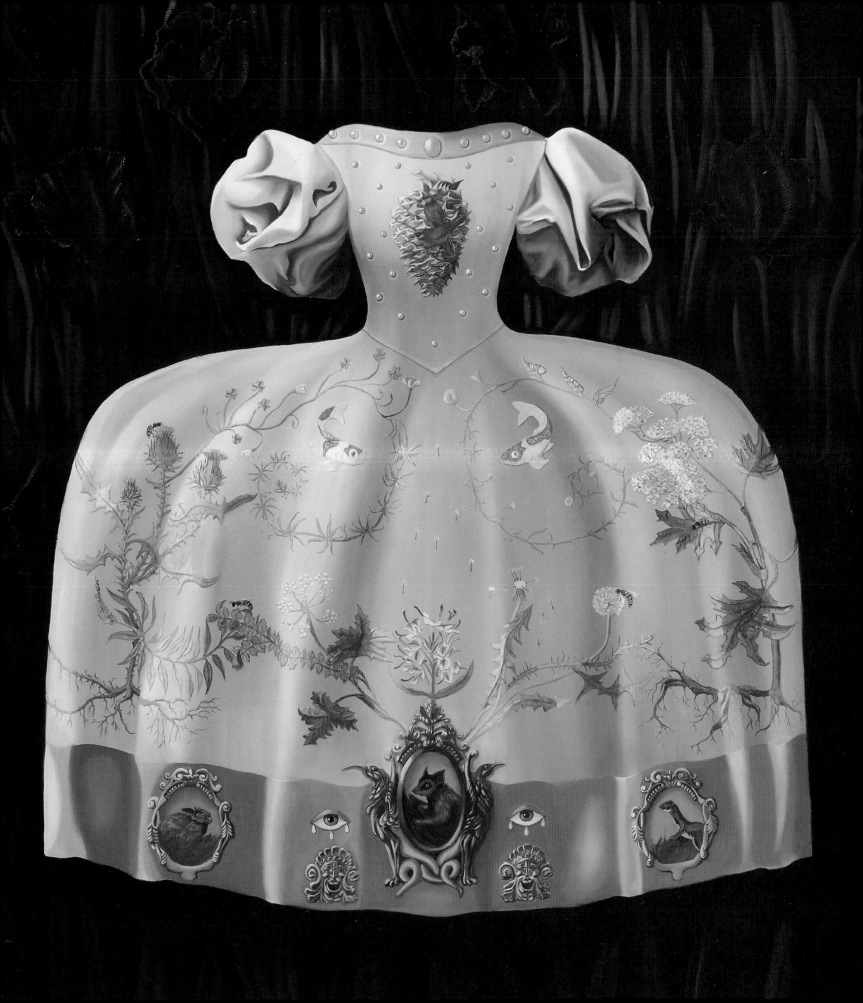

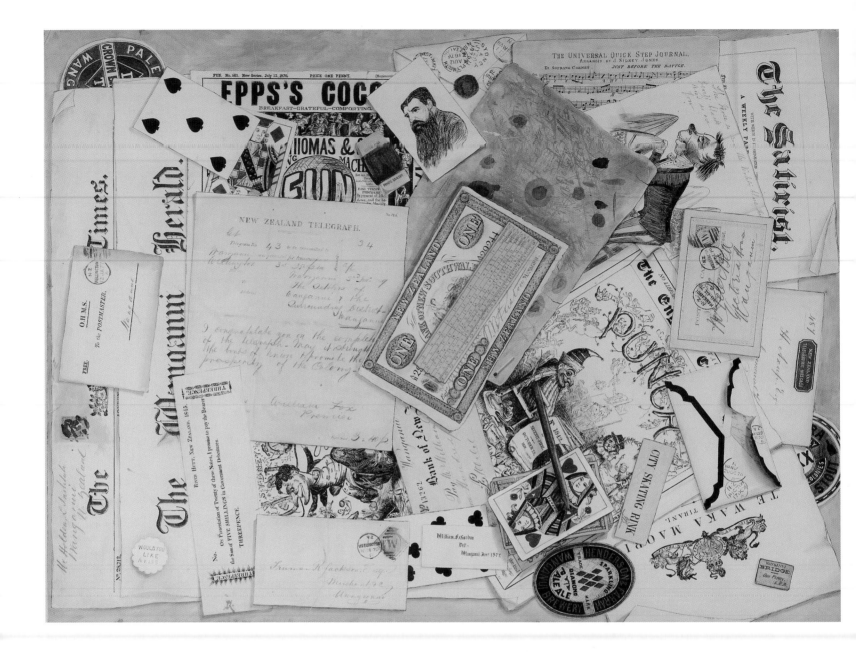

TROMPE L'OEIL (1877), a pencil, ink and watercolour drawing by W. F. Gordon (1848–1936). Born in Australia,
W. F. Gordon drew maps for the Survey Department in New Plymouth for 32 years, during which time he visited the Maori
leaders Te Whiti and Tohu at Parihaka. One of the few drawings ever made of Te Whiti was by Gordon, scribbled on the cuff of
his shirt during a visit to Parihaka – that portrait is the basis for the depiction of Te Whiti in this picture.

A desktop and a map

William F. Gordon's *Trompe l'oeil* (pronounced 'trom loo-ee') is a museum on a page – a collection of things. The picture (on left) preserves many details from life in Wanganui during the 1870s. It includes pages from the morning's newspaper, labels from beer bottles, cartoons and even a drawing of the Maori leader Te Whiti – he is the bearded figure near the top of the image. William F. Gordon's pick'n'mix also includes visiting cards, blotting paper, envelopes and a sheet of music. Maybe the picture is a kind of self-portrait – in which case you could be reasonably sure that William F. Gordon liked drinking beer, read a lot, had a good sense of humour and was interested in Maori culture . . . Maybe there wasn't much to do during the evenings in Wanganui at the time, so this kind of ultra-detailed pen-work was just the thing to while away the hours.

ABOVE: A SKETCH OF THE TOWN AND ENCAMPMENTS ROUND ABOUT TARANAKI (1860s), drawing on paper by Private Michael Horne.

In the nineteenth century there was a lot of sketching and painting going on around New Zealand as people recorded their travels, adventures and lives in general. Nothing is known about Michael Horne, who made the drawing on the right, apart from the fact he was a private in the 65th Regiment stationed in New Plymouth during the 1860s. (There were many young people in the army at this time – Private Horne was quite possibly a teenager.) At the foot of his imagined map of the city, a boat waits in the harbour, and the strange shape in the top right-hand corner might possibly be Mount Taranaki (or Egmont, as it was then known).

Two views of the mountain

Clear air, blue skies and lots of milk – that was how New Zealanders once liked to think of their country. When I was at primary school during the 1960s, all pupils had to drink a bottle of milk every day at morning break. New Zealand liked to think of itself as a country where everything was in good shape and in its proper place. That's very much how it is in Christopher Perkins's *Taranaki*, which he painted in 1931: the mountain slopes are milk-white and the dairy factory is clearly outlined (although a blanket of fog means you can't see the farmland and bush at the base of Mount Taranaki).

By the 1970s, virtually all of the small-town dairy factories like the one in this painting were closing down as big, centralised factories took over the production of milk, cheese and butter. Christopher Perkins's painting has become a memorial for something that we have now lost.

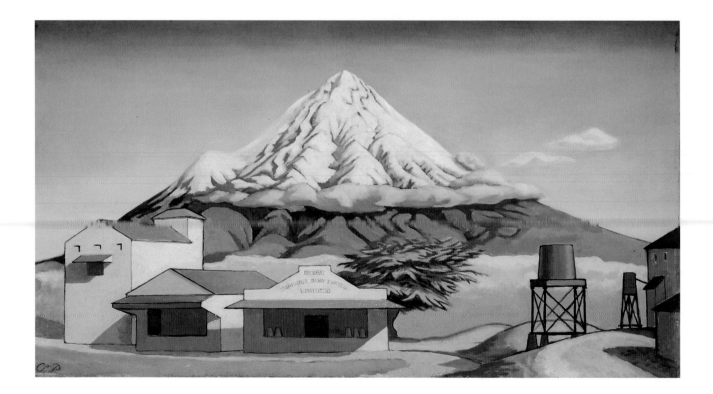

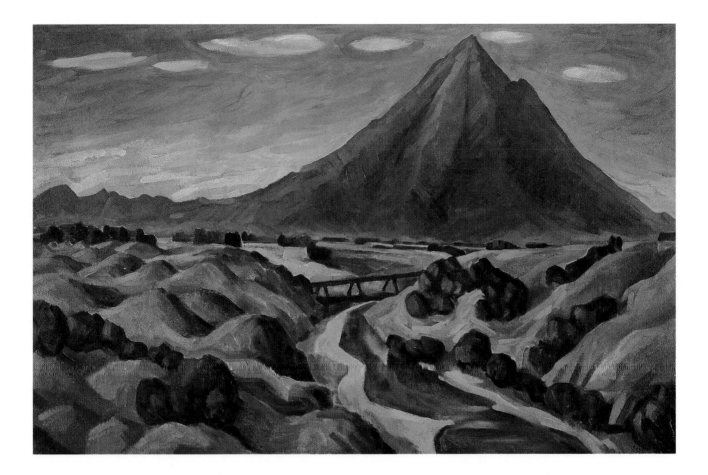

In contrast to the fertile, moist landscape in Christopher Perkins's painting, Doris Lusk paints Mount Taranaki in the middle of summer. Here, the fields are golden and there is no snow on the mountain. While Perkins's painting feels like the beginning of a cold winter's day, Lusk's picture conjures up a warm, languid afternoon. The little mounds which cover the land are called 'lahars' and were left behind by streams of lava when Mount Taranaki erupted thousands of years ago. After leaving Titirangi, the artist Elizabeth Thomson (see page 34) lived not far from where this painting was made and she says it was the perfect place to train for cross-country running because of all the ups and downs.

OPPOSITE: TARANAKI (1931), an oil on canvas painting by Christopher Perkins (1891–1968).

ABOVE: MT TARANAKI (1956), an oil on canvas on board painting by Doris Lusk (1916–90).

Reinventing New Zealand

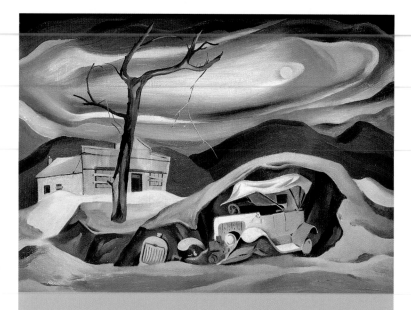

Derelicts, St Bathans **(c. 1947), an oil on hardboard painting by William Reed (1908–96).** The landscape around the small South Island town of St Bathans has long been a popular subject for painters. (Scientists also take an interest in the place on account of the discovery there of 16-million-year-old fossils of 3-metre-long crocodiles.) Hovering over a broken-down car and a boarded-up building in William Reed's painting, a dead tree stretches up towards the moon. After serving as a medic during World War II, William Reed worked as a teacher and frequently travelled around the South Island in search of subjects. He was a great painter of ghost towns, dead trees, strangely shaped shells and pieces of driftwood. He brought these things back to life.

As well as new people, new ideas about painting were also arriving in New Zealand around the middle of the twentieth century. In *Maori Meeting* (on right), Melvin Day painted a group of women he saw sitting outside a pa at Rotorua. It was a very ordinary topic for its time, although he painted the figures using a style typical of European modern artists – the sharp edges and diamond-forms are reminiscent of the Cubist and Futurist movements. The pattern which covers the surface of the painting also reminds me of the tukutuku panels you find on the walls of Maori meeting houses. With their woven criss-cross designs, tukutuku panels record family histories and tell ancient stories.

In the 1950s, Rotorua was the centre of some of the most exciting art being produced in New Zealand. As well as soaking up new ideas about art from overseas, Melvin Day and others were inspired by the mudpools, geysers, and the Maori culture and legends that surrounded them. In this painting, old meets new – and, since the middle of the twentieth century, that has been a recipe for some remarkable paintings.

MAORI MEETING (c. 1948), a tempera on cardboard painting by Melvin Day (born 1923).

Up above the world

In Felix Kelly's *Early Lineswoman* (on right), the ordinary world has been turned upside down. An elegant lady in a ballgown is lifting up telephone wires that hang above the roof of a typical New Zealand house. Sinister metal chimneys and a striped brick wall dominate the background. Perhaps there has been a flood or some other kind of natural disaster and she is trying to escape? It looks like pressure inside the chimneys is building up and they are about to explode. This picture was painted two years before World War II and you can feel the tension in the air.

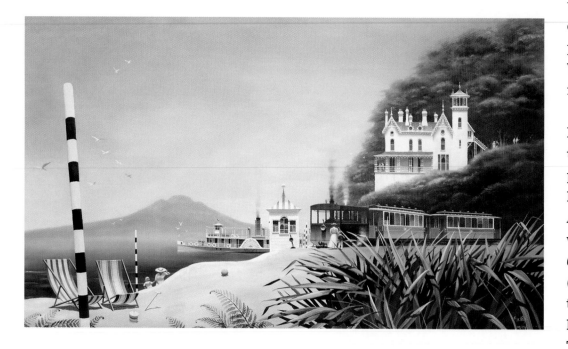

Having left New Zealand twenty years before he painted the picture, Felix Kelly conjured up the Auckland he knew when he was a boy in *A New Zealand Childhood Remembered* (1959). While the island in the background is definitely Rangitoto (seen from Takapuna), the foreground includes buildings from elsewhere, a tram, some typical New Zealand flaxbushes and some very English-looking trees. All these elements are ordinary on their own, but when you bring them together they become fantastical and otherworldly.

ABOVE: A NEW ZEALAND CHILDHOOD REMEMBERED (c. 1959), a tempera painting by Felix Kelly.

OPPOSITE: EARLY LINESWOMAN (1937), a gouache on paper painting by Felix Kelly (1914–94).

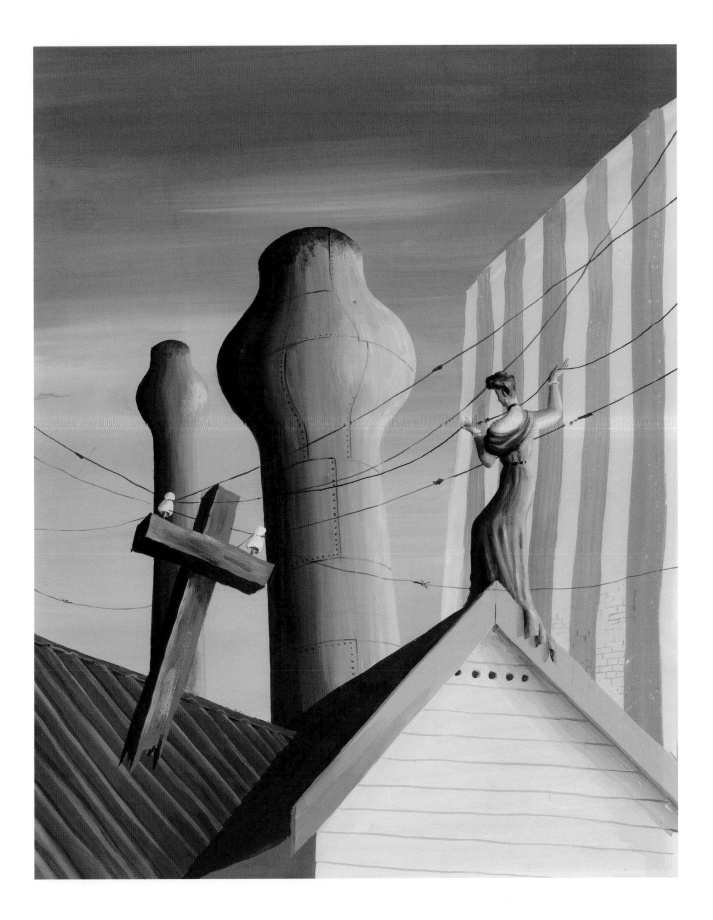

Citizens and Saints

As well as looking at the country and world around them, New Zealand painters have done a lot of looking at their communities, their families and, of course, themselves. During the twentieth century, artists found new and often surprising ways of seeing and painting people, often going beyond their outward appearances.

DESIGN (c. 1944), a varnished watercolour painting by A. Lois White (1903–84). The three women in Lois White's *Design* fit together like pieces of a jigsaw puzzle. They are three beauties you might have read about in Greek legends – usually known as the 'Three Graces'. They represent joy, beauty and charm, and were associated with painters and poets, as well as with dancing and public celebrations. This painting was made towards the end of World War II and the central woman is lifting up an offering – maybe a sign of thanks for the return of peace. During the war years, art materials were very difficult to come by in New Zealand. *Design* was painted in watercolours and the picture was then covered in varnish to make it look like an oil painting.

A toybox and a cake

It feels as if we have interrupted something here. Edith Collier's *Boy with Noah's Ark* (on right) is looking back towards us. He is dressed in a raincoat and a rain-hat. Behind him is a miniature Noah's Ark. He has gathered an armful of trumpets and horns with which to summon the animals of the world. Perhaps the imaginary rains are over, the floodwaters are subsiding and the animals are now disembarking from the boat. Look at the way the artist has crammed the painting full of things — it is like an overcrowded toybox. She captures the excitement of the boy's make-believe game by using bright, tropical colours — the blue of the ocean contrasting with a fiery red.

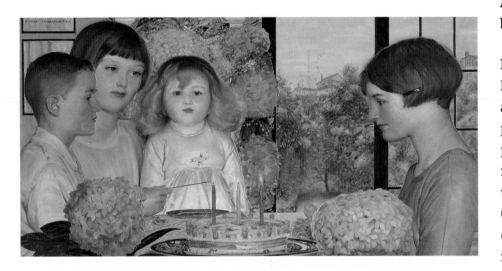

And the boy's cheeks are pink from blowing his trumpet.

Painted a decade later, H. Linley Richardson's *Cynthia's Birthday* is a puzzling depiction of a children's party. Maybe the young people in the painting were so tired of sitting still for the artist that they couldn't look as though they were enjoying themselves. Cynthia, the artist's youngest daughter, is facing us. (She looks as if she is having a slightly better time than the others.) But what are those hydrangea bushes doing at the party (they are the same size and shape as the heads of the children) – and why is the birthday cake surrounded by odd plastic babies?

ABOVE: CYNTHIA'S BIRTHDAY (c. 1926–27), an oil on canvas painting by H. Linley Richardson (1878–1947). Harry Linley Richardson was born in England and in 1908 emigrated to New Zealand, where he taught art and painted portraits, often using his own family as models.

OPPOSITE: BOY WITH NOAH'S ARK (c. 1916–17), a gouache on cardboard painting by Edith Collier (1885–1964).

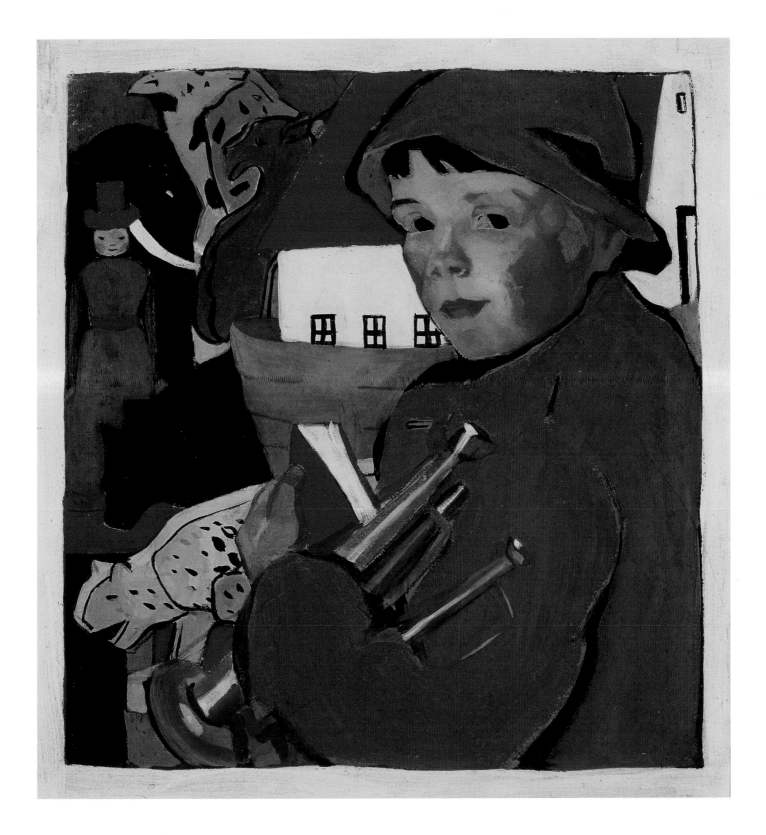

A self-portrait, a pile of cherished things

Frances Hodgkins was a wearer of interesting hats. That's her in the photograph on the left, racing towards us down a road in Holland. She looks as if she has a basket of fruit on her head. This photograph started me thinking about one of Frances's most famous paintings, *Self portrait: still life* (on right), and how this picture might in fact be a bird's-eye view of the contents of Frances's hat.

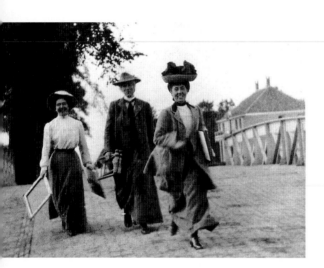

In a self-portrait, an artist usually paints their own face looking straight back at them. Here, Frances has taken a radically different approach. In fact, *Self portrait: still life* is two things at once: a 'still life' arrangement of objects (on a table-top or in a basket or a hat) and also a picture of the artist's personality. She uses cherished details from the world around her to tell us the kind of person she is. You'll find bright scarves, a high-heeled shoe, three roses on a leafy branch, a bowl and a belt. Frances delights in the shapes and colours as they swim around one another.

Frances Hodgkins was in her sixties when she painted this canvas. Late in her life, Frances's paintings were more energetic, colourful and original than ever. Painting remained a great adventure for her and, in the photograph above, she's holding tight to her art materials; a friend, following behind, is carrying her painting stool. You can be sure Frances is rushing ahead so that she can get started on the day's painting.

ABOVE: Photograph of the artist moving at speed, Frances Hodgkins in Holland, 1903, Auckland Art Gallery Toi o Tamaki.

OPPOSITE: SELF PORTRAIT: STILL LIFE (c. 1935), an oil on cardboard painting by Frances Hodgkins (1869–1947). Frances Hodgkins was born in Dunedin and painted her first watercolours in and around that city. Like many artists of her generation, she found it impossible to make a living here as a painter so she caught a boat to England in 1901 and spent most of her adult life there and in Europe.

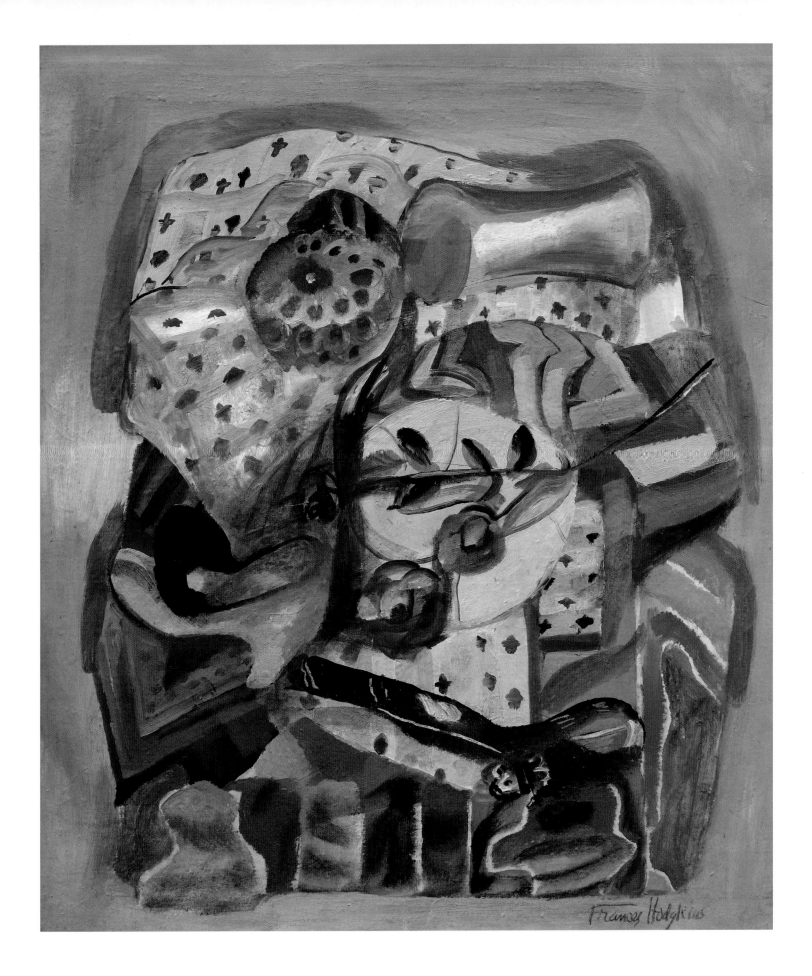

The immigrants

During and after World War II, many immigrants from Europe arrived in New Zealand. Douglas K. MacDiarmid's painting *The Immigrant* captures the sense of being out of place and ill at ease which many of these new arrivals felt. The woman in Douglas's painting is dressed in the European style and stands in a very modern piece of Christchurch architecture. In fact the living room and furniture in the painting are based on the designs of Ernst Plischke, an important Austrian architect who fled the Nazis and lived in New Zealand between 1939 and 1963. With the outside plant life creeping towards it, the house has the feeling of a space-craft that has landed on an alien planet.

Drawing for the *School Journal* (April 1948), by Russell Clark (1905–66). Russell Clark here lines up a variety of ocean-going boats as though they are swimmers at the Olympics. He has given them one lane each – and the race is over as soon as it has begun. The drawing is about emigration to New Zealand and a tailwind is blowing all the boats in this direction. Kupe and the Great Migration take gold and silver medals; and there is a bronze medal for Abel Tasman. Historians have altered the approximate dates of the arrival of Maori in New Zealand since this drawing was made, but one thing you can be sure of is that all the waka and sailing boats that came here had artists on board. There has been art in this country as long as there have been people here. And since Russell made this drawing, many other boats have docked, bringing new people and cultures to this country.

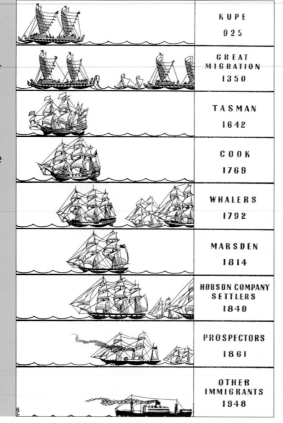

Not long after painting this picture, Douglas K. MacDiarmid became an immigrant himself. In the late 1940s he moved to Paris, where he still lives, paints and exhibits his work regularly.

THE IMMIGRANT (1945), an oil on canvas painting by Douglas K. MacDiarmid (born 1922).

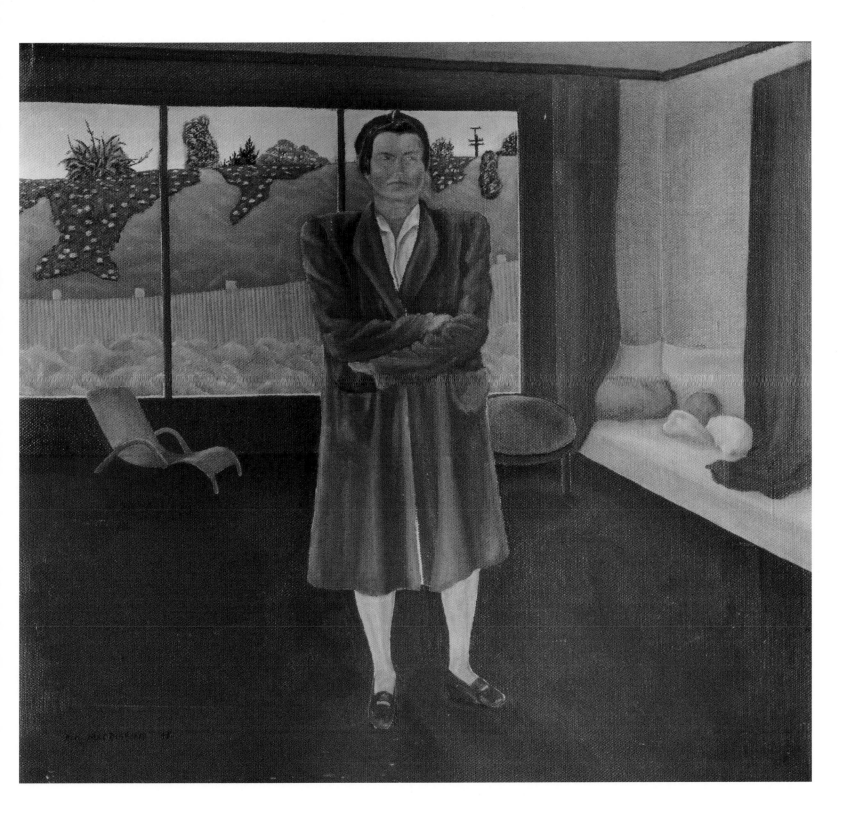

An angel over a landscape

An untitled drawing for the *School Journal* (c. 1940s), by Colin McCahon. Squalls of rain and shadows of clouds fall upon the hills in the background of this drawing, which is based on Otago Peninsula. Yet this is not New Zealand as we usually see it. Colin McCahon has dreamt up a few castles and, at the front of the picture, a figure in fancy dress is sitting in the bow of a boat.

A surprising number of angels have been painted hovering over the New Zealand countryside – and Colin McCahon is responsible for quite a few of them. He was aware that New Zealand had no grand tradition of religious art – in the Western sense – and he thought it was the duty of the painter to find a home for the characters and symbols of Christianity in a local setting. According to the New Testament, the annunciation was when an angel appeared to the Virgin Mary to tell her she would be giving birth to the Christ child. In Colin's *The Angel of the Annunciation*, the background hills are based on those around Nelson, where he worked during the 1940s, and the farmhouse behind the Virgin Mary is a typically New Zealand one.

For Colin McCahon painting was a very serious business. He wrote: 'I was very lucky and grew up knowing I would be a painter. I never had any doubts about this. I knew it as a very small boy and I knew it later . . . Painting to me is like lambs born in the spring, rain, wind, sun. Like chopping down trees in the wilderness . . .' Maybe, when he wrote that, he was thinking of Charles Heaphy's painting of tree-felling on page 49.

THE ANGEL OF THE ANNUNCIATION (1947), an oil on cardboard painting by Colin McCahon (1919–87).

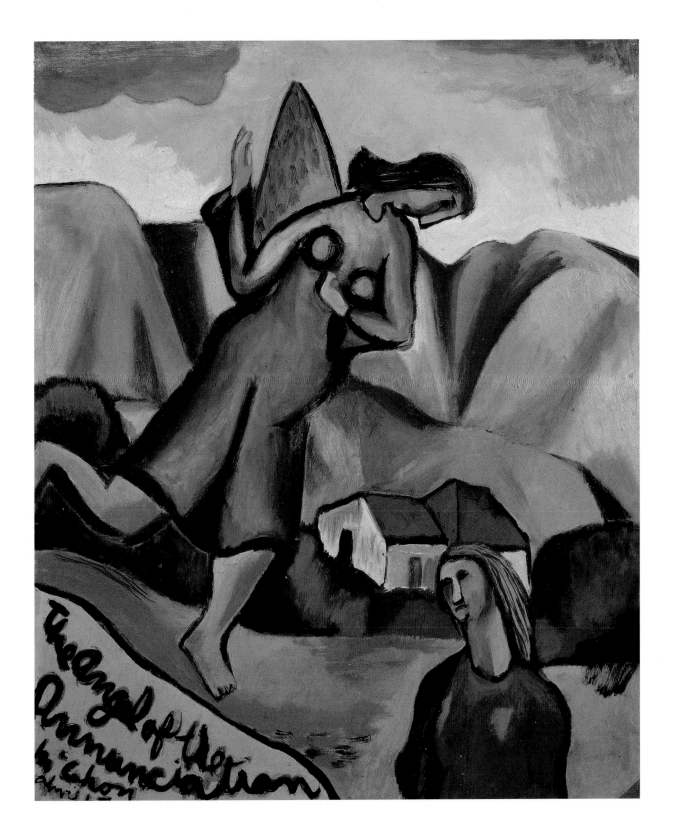

A goddess, a younger sister

Goddess of Mercy is said to be an imagined portrait of Rita Angus's younger sister, Edna, who died of asthma when she was only thirty years old. In the painting, Edna remains forever young. The painting is filled with images of shelter and tenderness: the jacketed cows and the deer lean lovingly against the girl. Roots dangling from the sky are drawing Edna up into the blue sky. She is a goddess but she is also a real person. In the early 1930s, Edna had learned to fly an aeroplane and was the first woman member of the East Coast Aero Club to become a licensed pilot. Maybe the sky was a place where she felt at home.

In Rita's painting, birds come flying towards us from the alps beyond, as though bringing messages from another world. Like her friend Colin McCahon, Rita wanted her paintings to have a religious feel – yet, instead of using biblical stories, she looked for subjects and symbols in the world around her. The young girl in this picture has stepped outside of earthly time. She is in a heavenly setting – a paradise that Rita created for her.

Like Rita Angus, Anne McCahon produced many drawings and designed covers (like the one on the left) for the *School Journal* during the 1950s. The money from these kept the family afloat at a time when her husband, Colin, was busy trying to establish himself as a painter. Other artists who produced work for the *School Journal* included Doris Lusk, John Drawbridge, Brent Wong, Graham Percy and Robyn Kahukiwa (you'll find their paintings elsewhere in this book). The tradition of painters producing great art for children's publications continues to this day – you just have to look at the work of illustrators such as Gavin Bishop, David Elliot, Bob Kerr, Peter Gossage and Christine Ross. Remember, the best children's book illustrations are serious pieces of art too.

ABOVE: Cover illustration for the *School Journal* Part 2, May 1954, by Anne McCahon (1915–93).

OPPOSITE: GODDESS OF MERCY (1946–47), an oil on canvas painting by Rita Angus (1908–70).

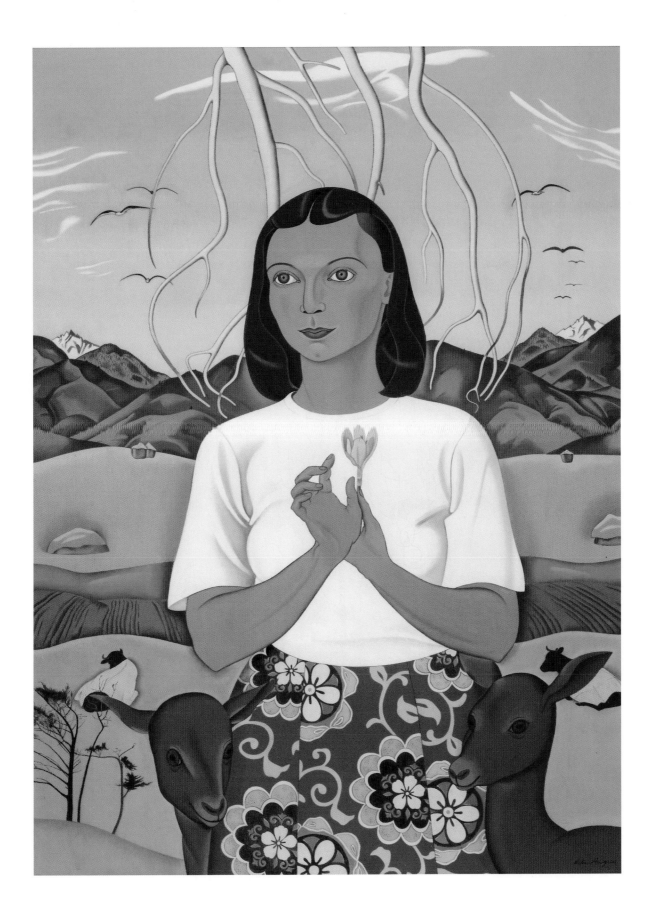

Ghouls, a girl and two grape-growers

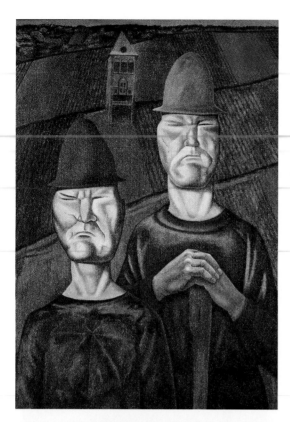

Early settlers arriving in New Zealand from Great Britain and Europe brought with them Shakespeare as well as the Bible. They also brought Grimm's Fairy Tales, *The Rime of the Ancient Mariner* and many other stories and fables. Leo Bensemann's paintings are a mixture of what he saw in the South Island landscape and characters from books he had read. The Bensemann family was from Northern Europe – Germany, to be exact – and there are echoes of his ancestral home in his work too.

Leo's drawing of Prospero (lower left) looks like something from Peter Jackson's film trilogy, *The Lord of the Rings*. The 'Shaky Islands' label certainly fits this depiction of razor-sharp mountains and cracked earth. At the same time that the ground is swallowing the ghoulish figures, it is forcing them back into the world. Leo Bensemann's art can be playful as well as terrifying. In *The Little Witch* (on right), the wispy girl is a cross between a not-very-wicked witch and a Christchurch schoolgirl – and in *Figures in a vineyard, Bacharach* (upper left), Leo turns two workers into squinting creatures with grape-like faces.

TOP LEFT: FIGURES IN A VINEYARD, BACHARACH (1980), an oil on hardboard painting by Leo Bensemann.

BOTTOM LEFT: PROSPERO (from *A Second Book of Leo Bensemann's Work*) (1952), a drawing by Leo Bensemann.

OPPOSITE: THE LITTLE WITCH (from *Fantastica*) (1937), a drawing by Leo Bensemann (1912–86).

Inside the mud-brick hut

It used to be tough being an artist in New Zealand. M. T. (Toss) Woollaston worked on orchards in the Nelson area before doing time as a door-to-door salesman. It wasn't until he was 57 years old that he finally managed to make a living from his art. Early in his career he built a mud hut for his family because they couldn't afford a proper house. He wrote a poem about it:

> Our children grew up jeered at
> by others for the mud-brick hut they lived in.
> But they liked the wide western door
> with afternoon sun shining in on the earth floor;
> and on the other side, the view through the unglazed window
> of the sharp mountain and the others,
> across the combed width of an orchard.

The plainness of their living arrangements is matched by the plainness and toughness of this painting. In *Figures from Life*, areas of the paper are left unpainted; the lines are drawn in charcoal with the colours painted in. Toss's paintings were never beautiful in the usual sense. As he had no money to buy quality art supplies, he frequently had to paint on old sheets of paper, cardboard and even on the insides of Weet-Bix packets. He usually painted the landscape that was just outside his door – or he painted his family and friends. That's his wife, Edith, on the right and his friend Rodney Kennedy on the left, and they are inside the mud-brick hut.

FIGURES FROM LIFE (1936), an oil and charcoal work on paper by M. T. Woollaston (1910–98).

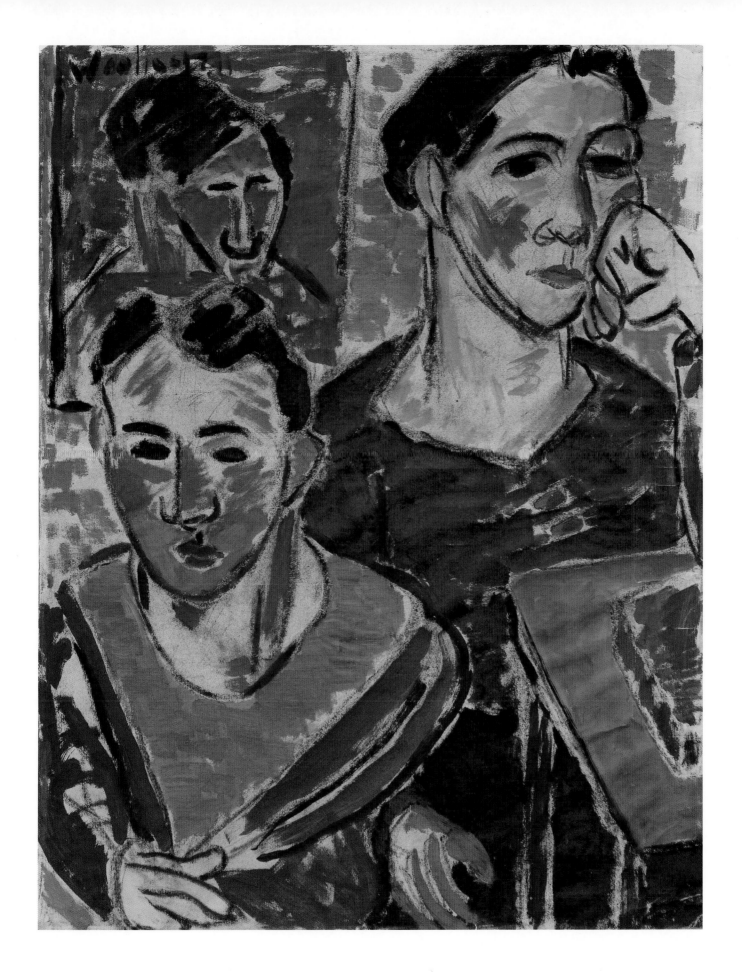

'The World's Fastest Indian' – the Patrick Hayman version

Patrick Hayman painted heroes and sometimes villains – characters from Shakespeare's plays, Captain Cook voyaging in the Pacific, pioneers of aviation and other adventurers. *The Indian Flier* (on right) is his tribute to the famous motorcycle racer from Invercargill, Bert Munro, who was the main character in the 2005 movie *The World's Fastest Indian*. Bert Munro built a motorcycle in his shed which he took to the Bonneville Salt Flats, in the United States of America, where he set a world speed record. It is a great story.

In *The Indian Flier*, Patrick Hayman has made a few modifications to Munro's classic 'Indian' motorcycle and the motorcycle-racer has become a bird-dragon. Pinned inside a display case, the creature looks like an exhibit in the natural history section of a museum. A doorknob – which looks distinctly like the front of Munro's racing motorbike – extends from the front of the bird-dragon.

People thought Bert Munro was crazy. He broke all the rules and succeeded. Many of the artists in this book were considered crazy by people around them – but they kept on doing what they believed in. And they succeeded. Patrick Hayman thought that his job as an artist was to fill the world with imagination and energy. Bert Munro would have got along well with him.

ON LEFT: Photograph of Patrick Hayman, swimming near Dunedin, 1937.

OPPOSITE: THE INDIAN FLIER (1980), an oil on wood construction by Patrick Hayman (1915–88). Patrick Hayman spent nearly a decade in New Zealand during the 1930s and 1940s. He became close friends with the artists M. T. Woollaston, Doris Lusk and Colin McCahon. *The Indian Flier* was included in an exhibition, 'Alive to it all', which toured Great Britain in 1983 and featured Patrick Hayman's work alongside that of such well-known international artists as Paul Klee, Joan Miró and Jackson Pollock.

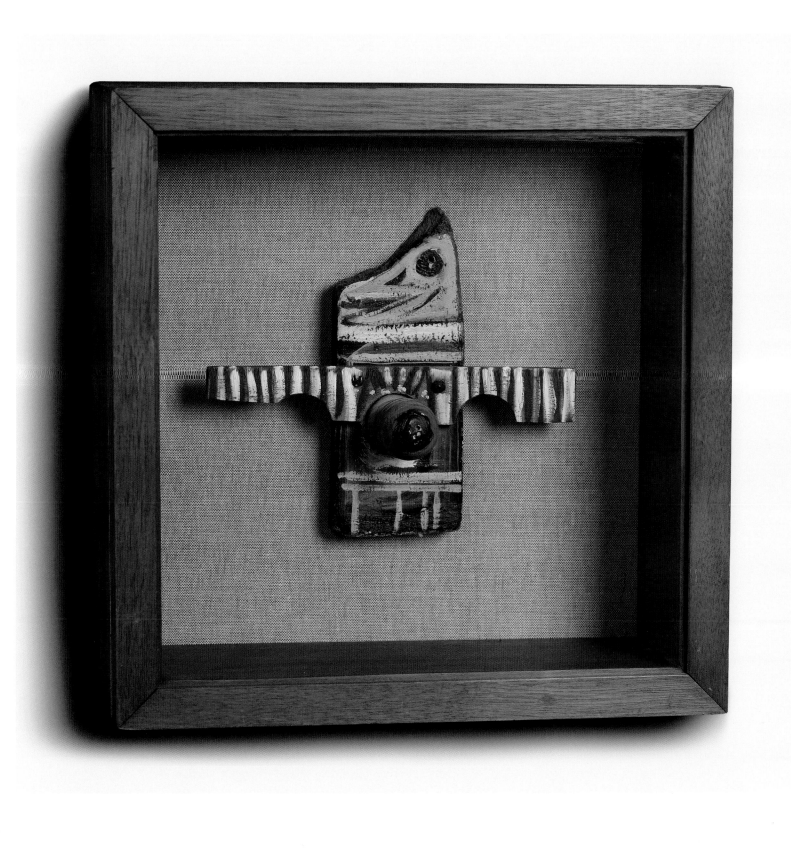

No Time like the Present

In recent decades artists have continued to explore the world around them. Finding out where you stand in the world still requires as much imagination and looking around as it ever did. Every great painting tells us something about the world we didn't know before. Every great painting is a discovery.

BIRDS OF A FEATHER (2005), an oil on canvas painting by Joanna Braithwaite (born 1962). When I was growing up, one of the most famous singing acts in New Zealand was a female duo called 'The Chicks'. In this self-portrait, the very bird-like Jo Braithwaite looks as if she might be in the middle of a song and dance routine, shimmying from right to left. Or maybe she is directing bird-traffic with her pointed finger? When you look at the clouds directly behind Jo in the painting, you realise she is actually high up in the air. Tiny fragments of blue sky can be seen through the tangle of sparrows that make up her body and arm – and she is glancing towards us, as if to ask, 'Well, am I any good at this? What do you think?'

A flying finish

Flight brings together some of Rita Angus's favourite subjects. While the hills in the background are those at Makara, not far from Wellington, the rocks and boats are based on those Rita would spend hours studying at Island Bay. The gravestones piled up at the front of the painting are those she sketched at a cemetery which was being demolished to make way for a motorway near the middle of the city. Like mischievous schoolgirls, Rita

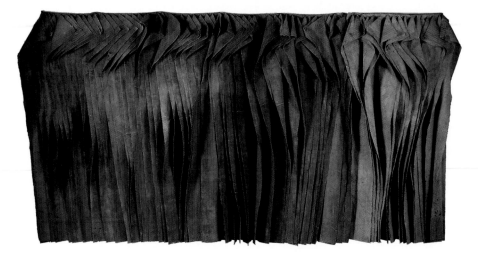

and her friend Juliet Peter (see pages 7 and 24) would sneak into the fenced-off area on weekends and draw the monuments.

Rita finished *Flight* shortly before her death – and maybe she somehow knew she didn't have long to live when she painted the stone dove with a leafy branch in its beak. Here the bird, which was based on a gravestone ornament, is taking flight – like the soul of someone departing from this life.

While artists like Rita Angus were finding new ways of painting pictures of the world, others were heading off in the direction of abstraction – of art in which there are no people, places or things you can recognise. Don Peebles is one of New Zealand's greatest abstract painters, yet his works do contain echoes of the real world. Like Rita, Don is spellbound by the colours, textures and rhythms of the environment around him. Instead of painting on a flat piece of canvas, he paints folds of material and assembles them so the painting is like a sculpture hanging on the wall. His works can resemble a bird's-eye view of the world, or they can be like waves of the sea, or, as is the case here, like entering a dark New Zealand forest.

ABOVE: UNTITLED BLUE/GREEN (1979), an acrylic on canvas painting by Don Peebles (born 1922).

OPPOSITE: FLIGHT (1969), an oil on hardboard painting by Rita Angus (1908–70).

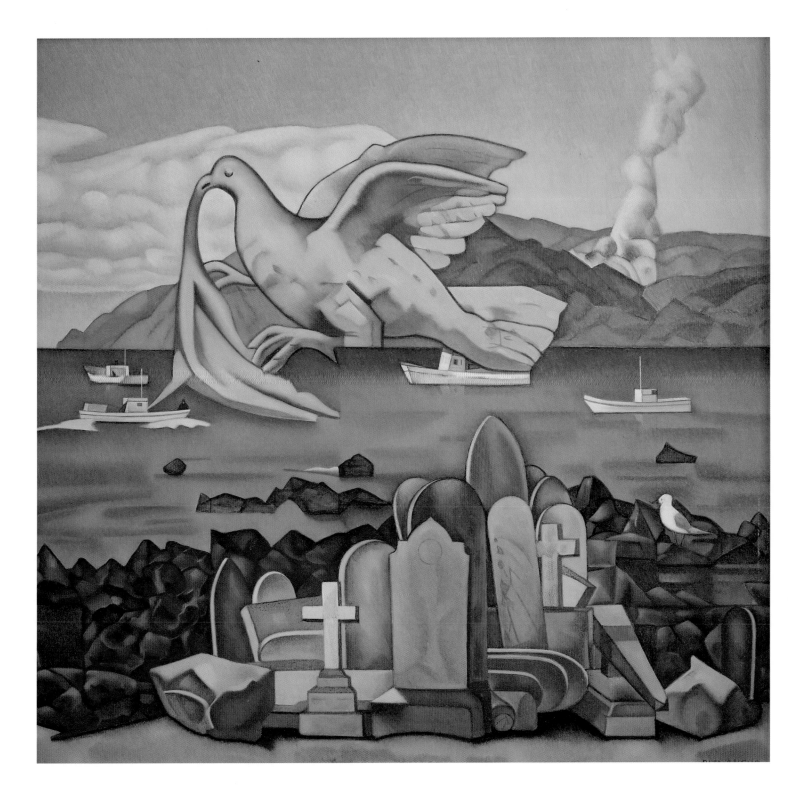

The place where we live

John Drawbridge's mural has survived for over four decades in the entranceway of the assembly hall at Evans Bay Intermediate School, Wellington. Without painting a single person, John conveyed a sense of the teeming human activity of the Evans Bay suburb and coastline. He believed a good mural should be a background for the life that was going on in front of it – so he had the bustle of schoolchildren on their way to assembly very much in mind when planning this. The pupils have, over the years, shown the work a lot of respect – it still shines, like something loved.

Evans Bay is not far from Wellington airport – hence the aeroplanes coming and going and the control tower. Since the mural was painted, not that much has changed in the suburb itself. The aeroplanes have got bigger; windsurfers and jet-skis have joined the sailboats in Evans Bay. You'll still find container ships moored at the Miramar Wharf (near the top of the painting). For the past few years the film-maker Peter Jackson has had the boat used in *King Kong* tied up there. The rugby posts are still around during the winter season. Using flat planes of colour and arranging rectangles into a patchwork pattern, John created a very modern work of art, full of movement and energy. Like Evans Bay, it all fits together perfectly.

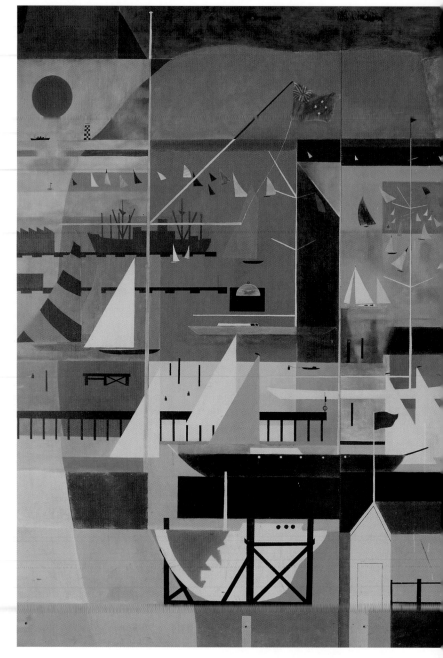

EVANS BAY MURAL (1965), an oil on hardboard mural at Evans Bay Intermediate School by John Drawbridge (1930–2005). Born in Wellington, John Drawbridge spent most of his life in that city, working much of the time in his studio at Island Bay, overlooking Cook Strait. As well as the Evans Bay Intermediate School mural, he made murals which are permanently displayed in the Beehive, at Archives New Zealand and in the foyer of the National Library.

Woollen jumpers and ancient stones

Helen Stewart's *Stable and woolshed* (on left) is all about the softness of the flock of sheep in the holding pens. In the painting, the sheep are reduced to mounds of whiteness, like balls of cotton wool. While many New Zealand painters have depicted this country as a stark, hard, heavy place, Helen painted it as though it was soft, warm and comfortable. You could almost imagine *Stable and woolshed* being knitted in wool – the hills are so very like a yellow jumper. Helen Stewart also painted interior scenes and was quite possibly New Zealand's greatest painter of comfortable furniture, of armchairs and couches.

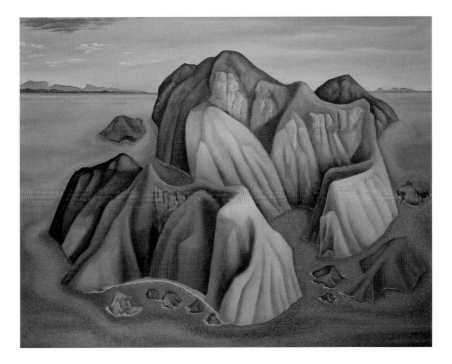

Like Helen Stewart, Leo Bensemann had a very personal way of seeing and feeling the landscape. In *Islands*, he places a swaying, dancing clump of land out in Golden Bay. The hills beyond Collingwood, in the Nelson district, are visible on the horizon. While the landforms look like bucking horses, Leo's shaky islands are in fact based on a very small piece of rock he photographed on the ground at Takaka then reimagined back in his studio.

OPPOSITE: STABLE AND WOOLSHED (c. 1970), an oil on hardboard painting by Helen Stewart (1900–83). Born in Wellington, Helen Stewart was taught by H. Linley Richardson (see page 64), but struck out in her own direction. She studied art in England and France (where she soaked up all the latest ideas about painting), then spent nearly two decades in Australia before returning to New Zealand in 1946.

ABOVE: ISLANDS (1983), an oil on hardboard painting by Leo Bensemann (1912–86).

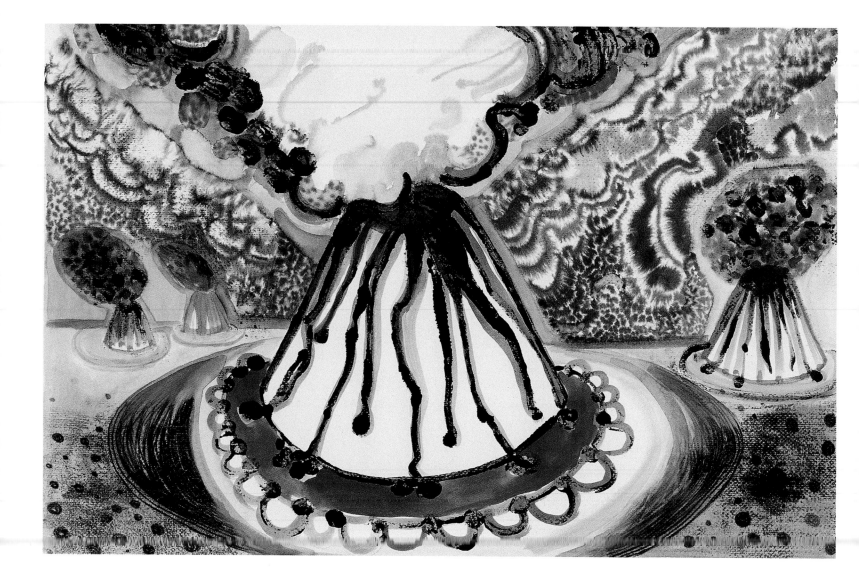

NGAURUHOE SNOW – AUNT DAISY, 'TASTE BEFORE EATING' SERIES (1982),
a monotype print by Marilynn Webb (born 1937, Ngapuhi).

A 'Shaky Island' recipe

Bringing together unlikely things in a single painting is a popular pursuit of artists in recent times. Marilynn Webb, in a group of images called 'Taste Before Eating', mixes up landscape and cooking, recipes and geography.

Marilynn has spent her life exploring the New Zealand landscape – mostly in Otago and Southland. She is alert to the myths – Maori and European – that the landscape contains. In the 'Taste Before Eating' series, she decided to have some fun with the whole idea of landscape art. In this picture (on left) Mount Ngauruhoe has become a dessert with chocolate trickling down the sides. The image is strewn with ink blots and a whole family of volcanoes is blasting away in the background. New Zealand must be a very shaky island indeed, if this picture is anything to go by. When exhibiting this image, Marilynn quotes, on the wall alongside, the recipe for Ngauruhoe Snow from the famous 'Aunt Daisy' cookbook:

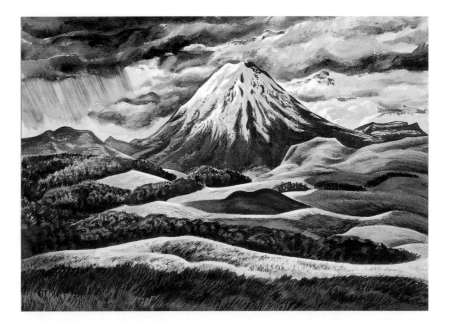

NGAURUHOE (1953), a watercolour painting by E. Mervyn Taylor (1906–64).

NGAURUHOE SNOW

Put round sponge cake on board. Beat 6 egg whites with wheel beater, until stiff enough to stand in peaks. Add a pinch of salt while beating. Have ready blocks of ice cream, and build them up on the sponge cake to represent a mountain. Stick this thickly all over with hulled strawberries. Fold into the beaten whites about half as much sugar as you would for meringues. Put the meringue thickly and thoroughly all over the ice cream and sponge cake. Put into a hot oven for a few minutes, until meringue is pretty brown. Remove mountain from oven, pour over the chocolate sauce to look like molten lava coming out of the crater. If for special occasions, heat some rum in the oven, and last thing, pour the hot rum over, set a match to it, put out the lights in the room and bring in the dish. – AUNT DAISY

Bird life

New Zealanders take birds very seriously – and I'm not just talking about kiwi and moa. In 2005, when Radio New Zealand announced they were planning to stop broadcasting the snippet of native birdsong before the 9 a.m. news, there was such a huge public outcry that they had to change their minds and leave the birds on the air.

Birds mean many things to many people. In the Christian tradition, the bird that usually hovers above holy places is a dove – which represents the Holy Spirit. In the painting on the right, Don Binney has deliberately flown a New Zealand kingfisher or kotare above the Ratana Church. He is saying we need to find our spiritual identity in this country and not just rely on beliefs and religions imported from other places. His bird is flying at speed – its lines look like those of a yacht or racing car. The church is solid and unmoving, but the bird is going places.

Like Don Binney, Johanna Pegler has spent a lot of time studying birds. In *Caterpillar* (on left), ducks drift in an orderly formation downstream, past a caterpillar-like clump of reeds. Johanna loves the landscape of the Coromandel Peninsula, and you can tell this by the way she has painted it: the clouds are like birds' wings in the sky above and the earth glows. Everything is in its place and the day drifts gently by.

ABOVE: CATERPILLAR (1995), an oil on canvas painting by Johanna Pegler (born 1965).

OPPOSITE: KOTARE OVER RATANA CHURCH, TE KAO (1964), an oil on board painting by Don Binney (born 1940).

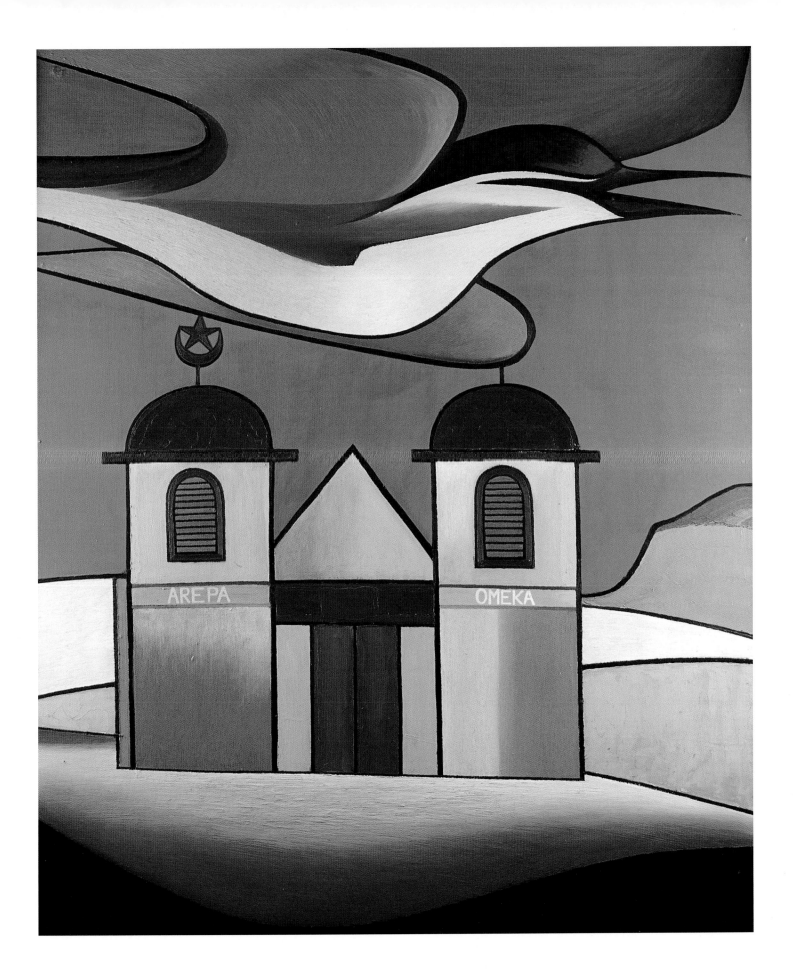

Moa-proof plant life

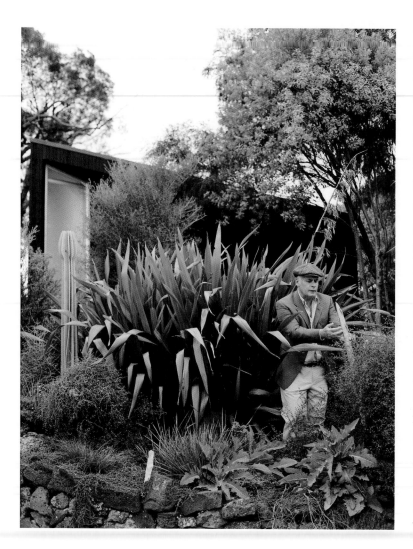

'For some millions of years, the moa in its various forms ranged across New Zealand,' writes the painter Michael Shepherd. 'For some 130,000 years of this time, the islands were seared by hot dry winds. Moa required huge amounts of vegetation and scientists believed that either the moa or the climate (perhaps both) caused the leaf mass of a large number of small plants to shrink or divaricate [which means to change]. Some plants evolved so that their leaves grew only when the plant had grown taller than an adult moa – that way the leaves were beyond the reach of the bird.'

In 2005 Michael Shepherd painted an entire exhibition of detailed portraits of these unpretty but very clever moa-proof plants. The paintings resemble pictures in a family photograph album. He obviously feels very affectionate towards these plants. His interest in them doesn't stop there, however. Around his recently built house in Onehunga, Auckland, Michael has planted a garden exclusively made up of plant species which adapted so that moa couldn't get them. His neighbours figure his garden will hold up very well if the moa ever return.

ABOVE: An artist in his natural habitat: Michael Shepherd in his garden full of moa-proof plants, photographed by Deborah Smith, 2007. Michael is looking at the cocoons of some native New Zealand moths on one of his beloved plants.

OPPOSITE: LANDSCAPE WITH DNA MARKERS (2005), an oil on board painting by Michael Shepherd (born 1950).

DINORNIS

Standing still and growing up at Okains Bay

The countryside can sure be an unsettling place for children. These children look frozen as if in a photograph and two of them have their hands tucked behind their backs as

though someone is telling them exactly how to stand. The baby isn't all that comfortable either. The sunlight is making them squint and the landscape around them is full of weird, unsettling patterns. The building behind them has no doors or windows. And where is the road in the painting leading – maybe towards the world of adulthood?

In the foreboding world of Jeffrey Harris's painting, branches and tree-stumps rise behind the children like tentacles. The children's clothing has the same texture and colour as the trees and everything is swept together by a mysterious wind.

Jeffrey Harris was born in Akaroa (not far from Okains Bay). His style of painting has varied over the past thirty years, but one thing that has never changed is the intensity. He often uses warm colours but the paintings still come out chilling. This painting is dated 1975–89. Fourteen years is a long time for a painting to sit around in an artist's studio – but Jeffrey Harris often works like that, revisiting and finishing paintings years after they were begun. By the time he completed this one, the three children had grown up and the baby had become a teenager.

THREE CHILDREN AT OKAINS BAY (1975–89), an oil on board painting by Jeffrey Harris (born 1949).

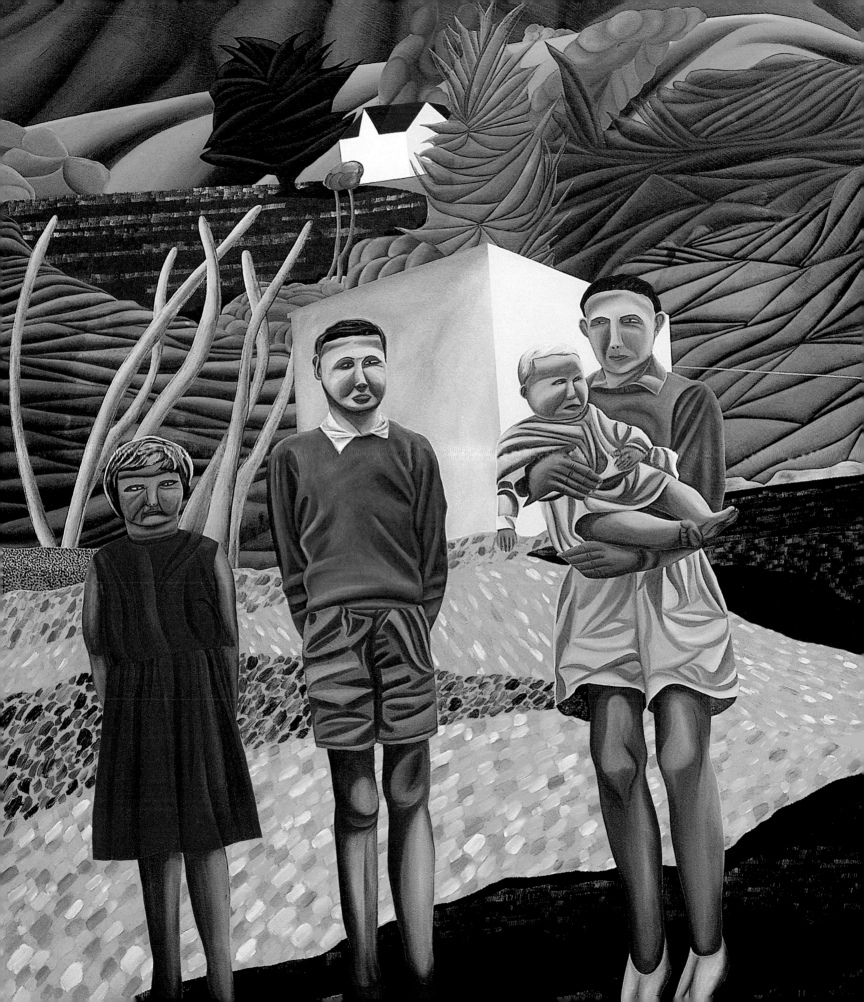

Late night inside the artist's studio

Self Portrait (c. 1969), an oil on hessian painting by Philip Clairmont. Born in Nelson in 1949, Philip Clairmont often painted on roughly textured jute or hessian canvas. Using bright colours and dramatic contrasts – purple next to green, yellow beside blue – his paintings have an immediacy and energy about them which makes you think he has only just finished painting them.

Philip Clairmont painted dizzying, dream-like and at times nightmarish pictures of the places where he lived and the objects that surrounded him. A fireplace here, an old couch there. In the picture on the right, a lightbulb dangles above a stairwell. (This painting is actually three paintings joined together to create a 'triptych'.) Philip was fascinated by artificial light, which, he said, was 'very different from natural light. It has more of the dramatic, more of the theatre about it. It calls up your own private universe.'

The world is spinning wildly around the electric lightbulb that hangs at the centre of each panel of this work. Everything is breaking up into wild patterns. In the right-hand panel the lightbulb has exploded. Yet the *Staircase Night Triptych* also has a beauty about it. Although it is night-time, colours seep out of the shadows. It is as if wild animals are breaking through the wood panels.

Staircase Night Triptych was painted in one long session, over three nights and two days. Maybe the electric colours are just how things start to look when you've been painting all through the night and your body is exhausted, your eyes hurting. Philip said: 'I think that paint itself is a magical substance. The act of remaking or transforming an object is magic. Paint has a life of its own if you are tuned in to it.'

STAIRCASE NIGHT TRIPTYCH (1978), acrylic and oil on jute painting by Philip Clairmont (1949–84).

New worlds replacing old

***Town Boundary* (1969), an oil on hardboard painting by Brent Wong (born 1945).** Brent Wong is a great painter of realistic pictures in which very unrealistic things happen. In the late 1960s, he became well known for his depictions of huge stone structures floating over New Zealand landscapes. At the time, people found them very surprising. Show this painting to a child today, however, and they'll shrug their shoulders and tell you the monumental cloud-shape is probably just a Lego construction or something from the book and movie *Howl's Moving Castle*. No problem.

Up until the time that rock band Split Enz became well known (this was back in the 1970s), it seemed to me that New Zealand music tended to copy what was happening overseas. Split Enz changed that. This painting, by Phil Judd who was a singer, guitarist and songwriter in the band, was reproduced on the cover of Split Enz's first record, *Mental Notes*.

I was still at school when I saw this record cover and it took my breath away. I didn't understand anything about it: the clown-faced baby, the sky seeping into everything. But that didn't matter, you could just sit back and enjoy the helter-skelter energy of the art (and the music too). It opened up a world of infinite strangeness and possibility. The band members (at the front of the picture), with their wind-blown ties and hair and their crumpled suits, were an inspiration. They looked like mad professors, minstrels from another time, clowns, crazy men – model citizens, you could say, of the 'Shaky Isles', a *new* New Zealand, where imagination is valued above all else.

COVER FOR MENTAL NOTES (1973–74), an acrylic on hardboard painting by Phil Judd (born 1953). This painting includes a self-portrait: that's Phil Judd in the middle of the group, his head shaven. (Tim Finn, who later performed with his brother Neil's band Crowded House, is on the lower left.)

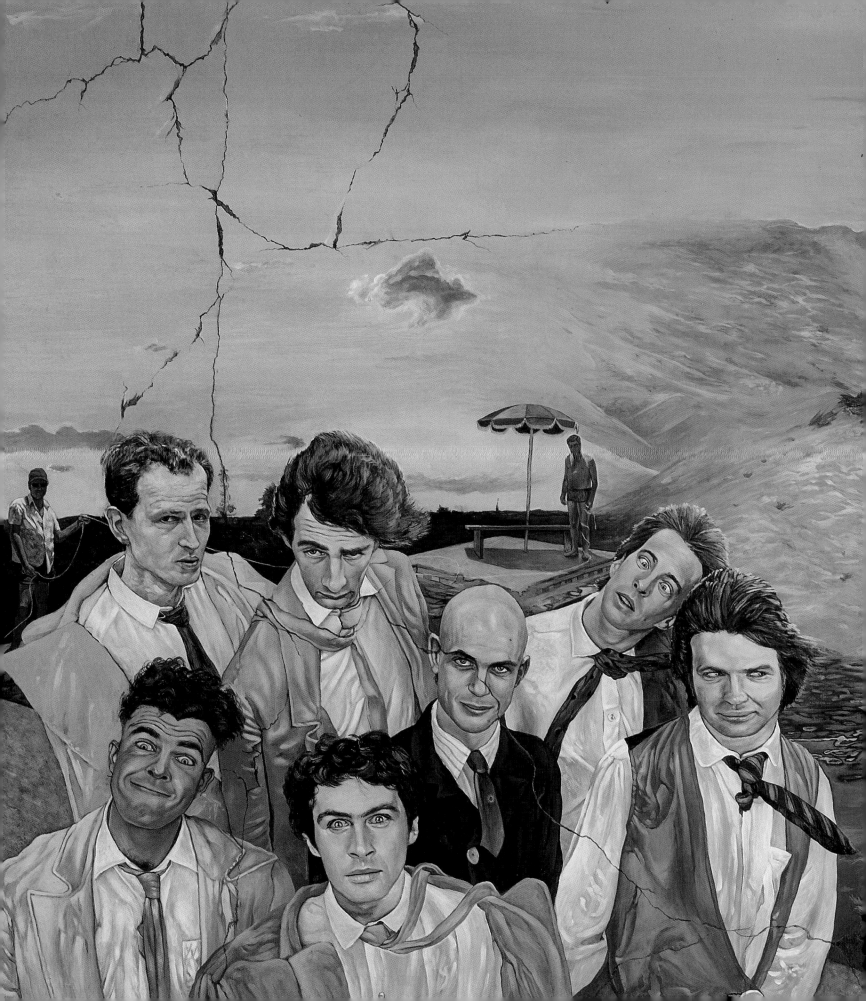

Winners and losers

That's Richard Lewer – the artist himself – in the middle of the picture on the right, heading towards us on spindly legs. He doesn't look up to tackling anyone – but that didn't stop Richard, when he was very young, winning the prize for Best Tackler of the Season in his rugby team. This was back in 1981. As a prize he got to be a ball-boy at a test match between the All Blacks and the Springboks in Hamilton (but that is another story). In the background, the creeping green plant life looks as if it wants to take over the house. And Richard doesn't look like such a great player. One leg is longer than the other, for a start.

If *Best Tackler* is about success, *Failure* is the opposite. It is painted on venetian blinds so if the owners get tired of the work they can open or raise the blinds and look at the wall behind, or out the window instead. Richard has drawn in marker pen on the blind and I think there's a joke here about the work being a 'drawn' blind.

ABOVE: FAILURE (2005), a drawing in marker pen on venetian blinds by Richard Lewer (born 1970).

OPPOSITE: BEST TACKLER (2005), a watercolour and PVA glue on canvas painting by Richard Lewer.

Leaving home – and what you take with you

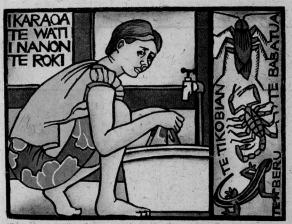

I KARAOA TE WATI I NANON TE ROKI

TE TIKOBIAN · TE BABATUA

TE ABEBERU · TE KIMOA

10/10 I am doing the washing in the bathroom. Robin White. 1983

I am doing the washing in the bathroom (1984), a hand-coloured woodblock print by Robin White (born 1946). Of Maori and Pakeha descent, Robin White lived for some years in the Pacific, on the island of Tarawa in the Republic of Kiribati, where she made woodcuts to record her experiences of learning the native language. At the right of this image, the Kiribati words for cockroach, scorpion and lizard are placed alongside the creatures themselves. For Robin, art can be a way of learning and passing on knowledge – and a way of celebrating such everyday tasks as doing the washing.

In _Take These With You When You Leave_ (on right), Niuean-born painter John Pule presents, at the bottom of the canvas, images from the myths and natural history of his birthplace – there are fish-symbols and bird-like creatures, eels and trees. All these things are linked to other shapes so the painting looks like an electrical circuit diagram or some kind of computer system. The painting is also like a map – not all that different from Michael Horne's on page 55.

As your eyes move further up the painting, you start recognising objects from the modern world. There is a car, a church and a boat, some boots, a ladder and a New Zealand passport. John also includes objects from the history of New Zealand art: there is a candleholder and jug which he probably based on those in paintings by Colin McCahon. In the top right-hand corner, hovering in front of a building, we find an angel – just like McCahon's famous angels that we encountered earlier (see pages 8 and 71).

The biggest object in the painting is an aeroplane which flies over the ocean. John is an immigrant to New Zealand and he uses his painting as a way of placing himself in his new home, while also acknowledging his family history and cultural origins back across the sea.

TAKE THESE WITH YOU WHEN YOU LEAVE (1998), an oil on canvas painting by John Pule (born 1962). John Pule was born on the Pacific island of Niue and arrived in New Zealand with his family in 1964. He also writes poetry and novels which, like his paintings and prints, stitch together all sorts of stories and histories. Some of his paintings resemble rugs that you could imagine wrapping around yourself. The stories and legends would keep you warm.

Strange birds and ordinary life

My mother used to say, when she came across someone who was out of the ordinary, 'he (or she) is a queer bird'. This was once a popular way of describing people who didn't exactly fit in. Bill Hammond's paintings often bring together elements from human life

and bird life. His paintings tell us a lot about the New Zealand character and imagination. His birds are capable of anything – they can be mischievous, bad-mannered or they can be delicate and full of song. The sky is the limit.

In *Rest Area Limbo Ledge*, Bill's birds perch on a cracked segment of the 'Shaky Islands' – or they drift like musical notes in the sky above. In contrast, Stanley Palmer's paintings and prints begin with the ordinary world around him. Yet Stanley's art depends on imagination and vision as well. His fenceposts and rustic buildings have a life of their own. And is that a bushfire or maybe even a volcano smoking away on the horizon? As different as the paintings of Bill Hammond and Stanley Palmer are, they both could only have been made in Aotearoa New Zealand. Both of them touch down on the soil of this country, while at the same time performing imaginative somersaults in the dizzying blue sky above.

ABOVE: REST AREA LIMBO LEDGE (2002), an acrylic on board painting
by Bill Hammond (born 1947).

OPPOSITE: JONES' FARM AFTER MILKING TIME (2006), a monoprint by Stanley Palmer (born 1936).

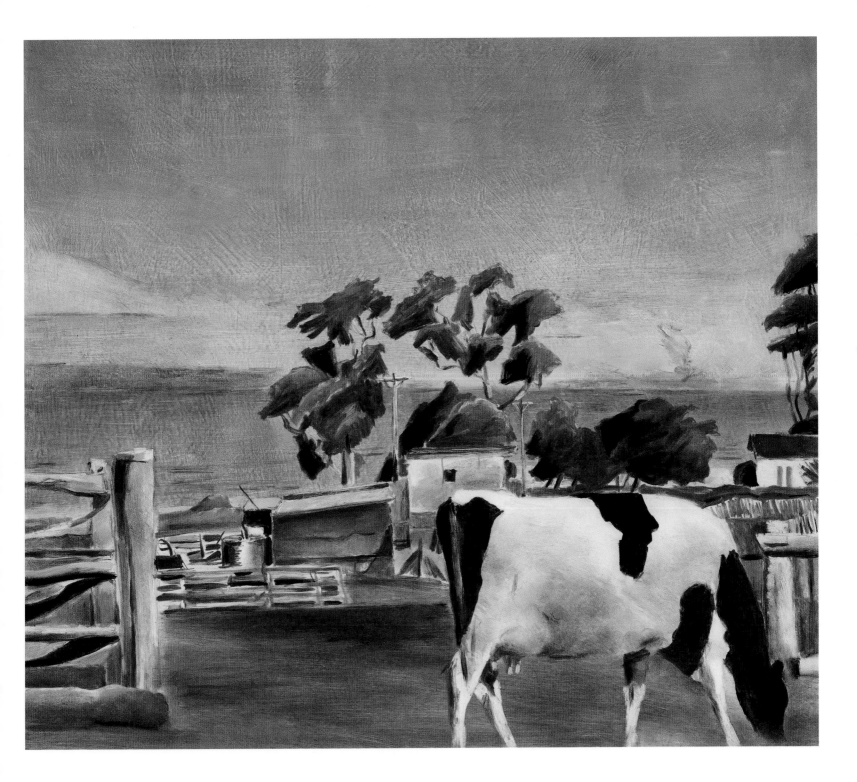

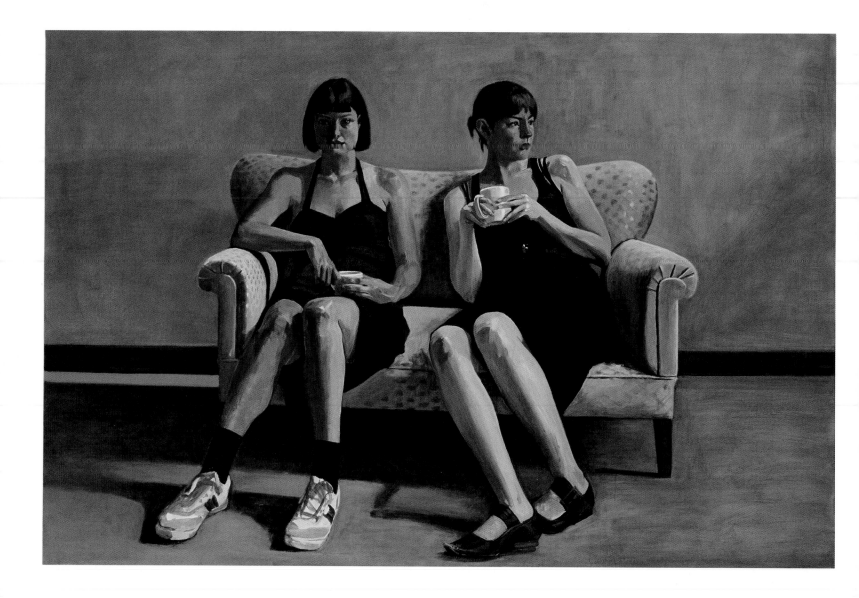

KATE & JULIA, BEING A PORTRAIT OF KATE SIMCOCK AND JULIA LOMAS (2007), an oil on canvas painting by Richard McWhannell (born 1952). Art is something to wonder about on your own or to talk to other people about. Kate and Julia don't quite seem to know what they're doing in this painting. At least the artist was considerate enough to give them each a cup of coffee. Kate is wearing sports shoes, whereas Julia is wearing what my friend Greta (aged 8) says are 'sensible, brainy shoes'. Kate is a little stroppier than Julia; she's fitter and has a tan. Maybe she's cross because they've been sitting so long and she would rather be outside. Julia, on the right, is more at home on the old-style couch. Perhaps they are both wondering what to do next?

Things to do now

1

'Don't just sit there, do something!' That is what I said to my sons as we sat at a long table near Waihi Beach with their friends, Geraldine and Greta. We had been looking at Frances Hodgkins's *Self portrait: still life* – see page 67 – which is made up of the scarves and things that meant a lot to Frances – and we were deciding which objects we would put in our own imaginary self-portraits. Felix said his 'self-portrait still life' would include a cat, tree, paintbrush, scooter, duck, book – whereas Carlo's picture would have a hedgehog, ball, shed, model soldier, fishing-rod and fish. Geraldine listed the following: a tree, a pencil, a paintbrush, a button, a necklace, a tenor horn, a musical note. Greta's list was made up of a piano, a bike, a netball, scissors, paper, glue and a cornet (guess what: these girls play brass instruments!).

This is a good exercise: make a list of 'cherished things' then draw or paint them on a sheet of paper. (Remember: the painting by Frances Hodgkins isn't the only 'self-portrait still life' in the book. See also W. F. Gordon's desktop on page 54 and John Pule's canvas on page 103.)

2

A lot of paintings bring together imagined stories and real history. Look at the pictures in this book and see if you can work out what the artist was imagining and what they were actually looking at. Sometimes artists base their work on old paintings and photographs as well as on the world in front of them (some of these sources are mentioned in the text alongside the paintings).

3

Painter Bill Hammond says New Zealand was once a 'Bird Land' – before humans took over. Early explorers, while still at sea, listened to deafeningly loud choruses of birdsong from the wooded coastline. See how many birds you can find in this book. Keep an eye out for some disguised, tattooed kiwi and, on the side of an urn, some Maori bird-men.

4

Birds aren't the only flying things in New Zealand art. How many winged, flying or falling figures can you find? (See if you can spot some airborne whales and outrigger canoes, a carved stone dove, a concrete architectural shape, the roots of a high altitude tree and an angel or three.)

5

Look closely at the surface of the pictures in this book. Some were made on paper – either with a pen, watercolours or using printmaking equipment. Take a close look at the pictures which are oil or acrylic on canvas or board. Look at the way the paint is put on – is it thick or thin, watery or solid? Can you see any brushmarks? How does the way that the paint is put on affect the way you see the image? (For an example of heavy painting look at Philip Clairmont – for thin paint on a rough surface look at Tony Fomison's *The Fugitive*; for waterish sheens of paint go to John Walsh's paintings.)

6

Earthquakes and eruptions are very much a part of life in the 'Shaky Islands'. See how many mountains and volcanoes you can find (a giant is relaxing in one, another is made of meringue). Keep an eye out for Mount Taranaki. Over the past two hundred years, many painters have been very interested in that particular mountain. The same mountain can look different depending on who is looking at and painting it.

7

As well as being discoverers, artists are collectors – and paintings are an opportunity to bring unexpected objects together. Good examples are Shane Cotton, Pat Hanly, W. F. Gordon, Frances Hodgkins and Rita Angus (in *Flight*). Which other artists collect or poozle in their work?

8

While some art historians say there is a lot of darkness in New Zealand painting, others make a point of talking about the crisp, bright New Zealand light which shines through, particularly in more recent art from this country. Looking through this book – do you think New Zealand is a light or a dark place? Is it a gloomy country or a joyful one? How has it changed over the past two hundred years?

9

Despite the fact most New Zealanders now live in cities, artists still make a great many paintings in which people are portrayed out in the landscape. Why do you think so many artists make work that is inspired by New Zealand mountains, farm-land and coast? Are we still getting used to living in cities – or does the natural New Zealand environment offer too many good subjects to pass up?

10

The women in Charles Heaphy's painting on page 40 – what could they possibly be shooting at?

Further information

Works reproduced in the book are here arranged alphabetically by the surname of the artist. Information about each work is followed by a list of books about the artist with general reference books listed at the end. Many of the artists featured in this book have works in public collections. The following websites include many reproductions of works:

www.aucklandartgallery.govt.nz
www.govettbrewster.com
www.city-gallery.org.nz
www.dunedin.art.museum
www.christchurchartgallery.org.nz
www.chartwell.org.nz

RITA ANGUS (1908–70) *Flight*, 1969, oil on hardboard, 583 x 589mm, collection of the Museum of New Zealand Te Papa Tongarewa, 1970-0012-1; *Goddess of Mercy*, 1946–47, oil on canvas, 866 x 615mm, collection of Christchurch Art Gallery Te Puna o Waiwhetu. Courtesy of the Estate of Rita Angus. Further Reading *Rita Angus: A Life*, Jill Trevelyan, 2008; *Rita Angus: Live to Paint, Paint to Live*, Jill Trevelyan and Vita Cochran, 2001; *Rita Angus*, ed. Janet Paul, 1982.

ANONYMOUS Maori rock drawing (as copied and reworked by Theo Schoon), undated, E150.319, Canterbury Museum. Further Reading *Maori Rock Art*, Michael Dunn, 1972.

ANONYMOUS *Maori in a canoe off shore near New Plymouth*, 1840s, oil on canvas, 530 x 632mm, National Library of Australia. Further Reading *Encounter with Eden: New Zealand 1770–1870*, Marian Minson, 1990.

LEO BENSEMANN (1912–86) *Figures in a vineyard, Bacharach*, 1980, oil on hardboard, 875 x 620mm; *Islands*, 1983, oil on hardboard, 500 x 620mm, University of Auckland Art Collection; *The Little Witch*, 1937, drawing, 523 x 379mm; *Prospero*, 1952, drawing, 375 x 285mm. Further Reading *Leo Bensemann: Portraits, Masks & Fantasy Figures*, Caroline Otto, 2005; *Leo Bensemann: Landscape and Studies*, Caroline Otto, 2006.

DON BINNEY (born 1940) *Kotare over Ratana Church, Te Kao*, 1964, oil on board, 1220 x 990mm, Dick Scott Collection, Auckland. Further Reading *Don Binney*, Damian Skinner, 2004.

JOANNA BRAITHWAITE (born 1962) *Birds of a Feather*, 2005, oil on canvas, 1300 x 1620 mm, private collection, Canterbury. Further Reading *Wonderland: Joanna Braithwaite*, Felicity Milburn and Justin Paton, 2005.

NIGEL BROWN (born 1949) *Dawn to Dusk (after Hodges)*, 1994, oil on board, 1170 x 1570mm, private collection. Further Reading *Nigel Brown*, Gregory O'Brien, 1990; *Truth Beyond Appearances: The Art of Nigel Brown*, Angela Vrede and Gill Harris, 2004.

JOHN BUCHANAN (1819–98) *Milford Sound, looking north-west from Freshwater Basin*, 1863, watercolour on paper, 225 x 509mm, Acc. No. A-444 Hocken Collections, Uare Taoka o Hakena, University of Otago.

EDWARD (TED) BULLMORE (1933–78) *Moahunters*, 1970, oil on board, 830 x 1238mm, 1995.65, Rotorua Museum of Art and History, Te Whare Taonga of Te Arawa, New Zealand.

MEGAN CAMPBELL (born 1956) *A Romantic View*, 2005, oil and bitumen on lino, c. 750 x 1500mm, photograph Norman Heke, collection of Jennifer Wood, Wellington.

PHILIP CLAIRMONT (1949–84) *Self Portrait*, c. 1969, oil on hessian, 1235 x 880mm, BNZ Art Collection; *Staircase Night Triptych*, 1978, acrylic and oil on jute, 1775 x 2820mm, Chartwell Collection, Auckland Art Gallery Toi o Tamaki. Copyright permission courtesy of Rachel Power. Further Reading *Philip Clairmont*, Jim and Mary Barr, 1987; *The Resurrection of Philip Clairmont*, Martin Edmond, 1999.

RUSSELL CLARK (1905–66) Drawing for the *School Journal*, late 1940s. Courtesy of Learning Media. Further Reading *The Drawings of Russell Clark*, Michael Dunn, 1976; *Russell Clark 1905–66: A Retrospective Exhibition*, Michael Dunn, 1975.

EDITH COLLIER (1885–1964) *Boy with Noah's Ark*, c. 1916–17, gouache on cardboard, 462 x 422mm, Edith Marion Collier Loan Collection, Sarjeant Gallery, Wanganui. Further Reading *Edith Collier: Her Life and Work 1885–1964*, Joanne Drayton, 1999.

SHANE COTTON (born 1964) *Tuna*, 1996, oil on canvas, 2005 x 1650mm, private collection. Further Reading *Shane Cotton*, Lara Strongman and others, 2004.

MARYROSE CROOK (born 1957) *The Sorrowful Eye: Pest Dress*, 2004, oil on canvas, 1370 x 1220mm, collection of the Southland Museum and Art Gallery.

MELVIN DAY (born 1923) *Maori Meeting*, c. 1948, tempera on cardboard, 420 x 370mm, collection of the artist. Further Reading *Melvin Day: Continuum*, Gregory O'Brien and Mark Hutchins, 2004.

TONY DE LAUTOUR (born 1965) *Peaceable Kingdom*, 2002, acrylic and oil on canvas, c. 320 x 400mm; *Settling Scores*, 1995, acrylic on saw, 1095 x 90mm, private collection, Wellington.

JOHN DRAWBRIDGE (1930–2005) *Evans Bay Mural*, 1965, oil on hardboard, 2800 x 5600mm, collection of Evans Bay Intermediate School, photograph Norman Heke. Further Reading *John Drawbridge: Wide Open Interior*, Gregory O'Brien and others, 2001.

TONY FOMISON (1939–90) *Nga Toki Mate Whenua*, 1983, oil on hessian, 804 x 1058mm, Chartwell Collection, Auckland Art Gallery Toi o Tamaki; *The Fugitive* (1981–83), oil on hessian over board, 1230 x 1830mm, BNZ Art Collection. Further Reading *Fomison: What Shall We Tell Them?* Ian Wedde and others, 1994.

WILLIAM F. GORDON (1848–1936) *Trompe l'oeil*, January 1877, pencil, ink and watercolour, 530 x 710mm, collection of Auckland Art Gallery Toi o Tamaki, the Ilene and Laurence Dakin Bequest, 1998. Further Reading *Stray Leaves: Colonial Trompe L'Oeil Drawings*, Roger Blackley, 2001.

BILL HAMMOND (born 1947) *Rest Area Limbo Ledge*, 2002, acrylic on a three-panel board, 1125 x 2090mm (open), Chartwell Collection, Auckland Art Gallery Toi o Tamaki. Further Reading *Bill Hammond: 23 Big Pictures*, Justin Paton and others, 1999; *Bill Hammond: Jingle Jangle Morning*, Jennifer Hay and others, 2007.

PAT HANLY (1932–2004) *Wonder Full* (1983), acrylic and enamel on board, 1190 x 1190mm, Chartwell Collection, Auckland Art Gallery Toi o Tamaki. Further Reading *Hanly*, Russell Haley, 1991.

JEFFREY HARRIS (born 1949) *Three children at Okains Bay*, 1975–89, oil on board, 955 x 1260mm, private collection. **Further Reading** *Jeffrey Harris*, Justin Paton, 2005.

PATRICK HAYMAN (1915–88) *The Indian Flier*, 1980, oil on wood, 330 x 330mm, photograph Norman Heke, private collection, Auckland. **Further Reading** *Patrick Hayman: Visionary Artist*, Mel Gooding, 2007.

CHARLES HEAPHY (1820–81) *Kauri forest, Wairoa River, Kaipara*, 1839, watercolour, 430 x 375mm, C-025-014, Drawings and Prints Collection, Alexander Turnbull Library; *Shooting party, Mansion House, Kawau Island*, 1853, watercolour, 67 x 90mm, A-164-046, Drawings and Prints Collection, Alexander Turnbull Library.

FRANCES HODGKINS (1869–1947) *Self portrait: still life*, c. 1935, oil on cardboard, 762 x 635mm, collection of Auckland Art Gallery Toi o Tamaki. **Further Reading** *Frances Hodgkins: Paintings and Drawings*, Iain Buchanan, Michael Dunn and Elizabeth Eastmond, 1994.

MICHAEL HORNE (dates unknown) *A sketch of the town and encampments round about Taranaki*, 1860s, sketch on paper, fMS-231-41, Manuscripts and Archives Collection, Alexander Turnbull Library, Wellington.

ALEXIS HUNTER (born 1948) *Creation*, 1987, oil on canvas, 2385 x 2610mm, collection of the Museum of New Zealand Te Papa Tongarewa, 1997-0032-1, licensed by VISCOPY, Australia, 2007, and courtesy of the artist. **Further Reading** *Fears/Dreams/ Desires: A Survey Exhibition*, Alexa M. Johnston and Elizabeth Eastmond, 1989.

PHIL JUDD (born 1953) Cover for *Mental Notes*, 1973–74, acrylic on hardboard, 465 x 932mm, collection of the Museum of New Zealand Te Papa Tongarewa, 1995-0001-1.

ROBYN KAHUKIWA (born 1940) *Hine-titama*, 1980, oil on board, 1314 x 1318mm, collection of Te Manawa, courtesy of Te Manawa Art Society Incorporated. **Further Reading** *Wahine Toa: Women of Maori myth*, Robyn Kahukiwa and Patricia Grace, 1984; *Paikea*, Robyn Kahukiwa, 1991; *The Art of Robyn Kahukiwa*, 2005.

FELIX KELLY (1914–94) *Early Lineswoman*, 1937, gouache on paper, 310 x 240mm, private collection, Auckland; *A New Zealand Childhood Remembered*, c. 1959, tempera, 1190 x 1970mm, collection of

Leslie Peacock, Wellington. **Further Reading** *Fix: The Art and Life of Felix Kelly*, Donald Bassett, 2006.

SASKIA LEEK (born 1970) *Untitled* (study for *Picnic at Woodhaugh*), 2004, acrylic and pencil on wood, 240 x 370mm, photograph Norman Heke, private collection, Wellington.

RICHARD LEWER (born 1970) *Desi Tuckler*, 2005, watercolour and PVA on canvas, 750 x 750mm; *Failure*, 2005, marker on venetian blinds, 1200 x 1500mm.

TREVOR LLOYD (c. 1863–1937) *Death of a moa*, c. 1925, watercolour, 520 x 380mm, collection of Auckland Art Gallery Toi o Tamaki, bequest of Miss Connie Lloyd, 1983.

DORIS LUSK (1916–90) *Mt Taranaki*, 1956, oil on canvas on board, 600 x 900mm, private collection. **Further Reading** *Landmarks: The Landscape Paintings of Doris Lusk*, Lisa Beaven and Grant Banbury, 1996.

LEN LYE (1901–80) *Fern People*, 1946, oil on plywood, 925 x 1426mm, photograph Bryan James, collection of the Govett-Brewster Art Gallery, New Plymouth; stills from *Tusalava*, 1928. Courtesy of the Len Lye Trust. **Further Reading** *Len Lye*, Roger Horrocks, 2001; *Figures of Motion*, Len Lye, 1984.

ANNE McCAHON (1915–93) Cover illustration for *School Journal* Part 2, May 1954. Courtesy of Learning Media.

COLIN McCAHON (1919–87) *The Angel of the Annunciation*, 1947, oil on cardboard, 647 x 521mm, Collection of the Museum of New Zealand Te Papa Tongarewa, 1980-0008-3; *The Sunday Morning Angel*, 1948, ink on paper, 255 x 200mm, photograph Norman Heke, private collection. Courtesy of the Colin McCahon Research and Publication Trust. *Untitled* drawing, c. 1940s, for the *School Journal*. Courtesy of Archives New Zealand. **Further Reading** *Colin McCahon: A Question of Faith*, ed. Marja Bloem and Martin Browne, 2002

DOUGLAS MacDIARMID (born 1922) *The Immigrant*, 1945, oil on canvas on board, 374 x 400mm, collection of TheNewDowse, 1978.19.1.

EUAN MACLEOD (born 1956) *Spa*, 2005, oil on canvas, 1370 x 1800mm, private collection; *Barrow Man*, 2007, oil on canvas, 1320 x 1240mm. Courtesy of Bowen Galleries, Wellington. **Further Reading** *Napoleon Reef: Paintings 1992–2002*, Euan Macleod, 2002.

RICHARD McWHANNELL (born 1952) *Kate & Julia, being a portrait of Kate Simcock and Julia Lomas*, 2007, oil on canvas, 1215 x 1830mm. Courtesy of John Leech Gallery, Auckland. **Further Reading** *Richard McWhannell*, Lara Strongman, 1991.

MARIAN MAGUIRE (born 1962) *Attic Volute Crater, 1779, Depicting Scenes from the Odyssey of Captain Cook*, 2005, lithograph, 700 x 570mm; *Mount Egmont from the Southward*, 2004, lithograph, 398 x 637mm. Courtesy of the artist and Papergraphica. **Further Reading** *The Odyssey of Captain Cook*, Marian Maguire and Anna Smith, 2005.

CHARLES MERYON (1821–68) *Ministere de la Marine, Admiralty-Office*, 1865, etching, 169 x 147mm. **Further Reading** *Charles Meryon: A Life*, Roger Collins, 1999.

STANLEY PALMER (born 1936) *Jones' Farm After Milking Time*, 2006, monoprint, 485 x 535mm. Courtesy of the artist. **Further Reading** *Stanley Palmer: Poor Knights*, Riemke Ensing, 1992; *West: Stanley Palmer*, 2000; *To the Harbour*, Stanley Palmer, 2007.

SYDNEY PARKINSON (c. 1745–71) *View of an Arched Rock, on the Coast of New Zealand; with an Hippa, or Place of Retreat, on the Top of it*, 1773, hand-coloured engraving by James Newton based on a drawing by Sydney Parkinson, 225 x 270mm, PUBL-0037-24, Drawings and Prints Collection, Alexander Turnbull Library.

DON PEEBLES (born 1922) *Untitled Blue/Green*, 1979, acrylic on canvas, 1800 x 3210mm, photograph Bryan James, collection of the Govett-Brewster Art Gallery, New Plymouth. **Further Reading** *Don Peebles*, Justin Paton, 1996.

JOHANNA PEGLER (born 1965) *Caterpillar*, 1995, oil on canvas, 455 x 830mm, private collection. **Further Reading** *Biophilia*, Greg Donson and Geoff Park, 2007.

CHRISTOPHER PERKINS (1891–1968) *Taranaki*, 1931, oil on canvas, 508 x 914mm, collection of Auckland Art Gallery Toi o Tamaki.

GRAHAM PERCY (1938–2008) *To get into where the wild pigs live . . .* , 2005, ink and acrylic on paper, 460 x 440mm, photograph Norman Heke; *The Kiwis in Paris*, 2004, ink on paper, c. 200 x 250mm; *The variegated Kiwi specially bred for Royalty*, 2004, ink on paper, c. 200 x 250mm. Courtesy of the artist. **Further Reading** *Arthouse*, 1993; *Imagined Histories*, 2007.

JULIET PETER (born 1915) 'Rona and the Moon', cover drawing for *School Journal* Vol. 40, No. 7, Part 2, August 1946; undated *School Journal* illustration, late 1940s. Courtesy of the artist and Learning Media.

JOEL SAMUEL POLACK (1807–82) *The North Cape, New Zealand, and Sperm Whale Fishery*, 1838, engraving, 95 x 155mm, A-032-026, Drawings and Prints Collection, Alexander Turnbull Library.

JANE POUNTNEY (1949–2004) *White Terraces*, 1992, oil on canvas, 1800mm diameter, New Zealand Post Art Collection.

JOHN PULE (born 1962) *Take These With You When You Leave*, 1998, oil on canvas, 1980 x 1850mm, Chartwell Collection, Auckland Art Gallery Toi o Tamaki.

WILLIAM REED (1908–96) *Derelicts, St Bathans*, c. 1947, oil on hardboard, 450 x 605mm, collection of the Christchurch Art Gallery Te Puna o Waiwhetu, purchased 1981.

H. LINLEY RICHARDSON (1878–1947) *Cynthia's Birthday*, c. 1926–27, oil on canvas, 657 x 1275mm, collection of the Christchurch Art Gallery Te Puna o Waiwhetu, presented by the Canterbury Society of Arts, 1932.

MICHAEL SHEPHERD (born 1950) *Landscape with DNA Markers*, 2005, oil on board, 345 x 215mm. Further Reading *Excavating the Past: Michael Shepherd, Artist*, Claudia Bell, 2005.

HELEN STEWART (1900–83) *Stable and woolshed*, c. 1970, oil on hardboard, 750 x 925mm, BNZ Art Collection. Further Reading *Gateways of Harmony*, Adrienne Jarvis, 2000.

GRAHAME SYDNEY (born 1948) *Dogtrials Bar*, 1977, egg tempera on gesso, 360mm x 680mm, private collection, London. Courtesy of the artist. Further Reading *The Art of Grahame Sydney*, Grahame Sydney and others, 2000.

HARIATA ROPATA TANGAHOE (born 1952) *Purere hua (Moth lady)*, 2004, acrylic on canvas, collection of the Ministry of Foreign Affairs and Trade; *Self portrait*, 1982, oil on hessian on hardboard, 770 x 890mm, BNZ Art Collection.

E. MERVYN TAYLOR (1906–64) *Nga Huia (Huias)*, 1949, Southland beech engraving, 104 x 154mm; *Ngauruhoe*, 1953, watercolour, 380 x 580mm; *Spiny Murex*, 1944, boxwood engraving, 76 x 64mm; *The*

Magical Wooden Head, 1952, boxwood engraving, 202 x 142mm. Further Reading *E. Mervyn Taylor: Artist, Craftsman*, Bryan James, 2006.

ELIZABETH THOMSON (born 1955) *Manukau Heads*, 1987, photo-etching, 695 x 935mm, collection of the artist; *Koromiko*, 2003, bronze, patina, flamed lime wash on fibro-cement panel, 950 x 620 x 150mm, private collection, Wellington. Further Reading *Elizabeth Thomson: My Hi-fi My Sci-fi*, Gregory O'Brien, 2006.

CHARLES TOLE (1903–88) *Kaisei Maru*, 1967–75, oil on hardboard, 472 x 595mm, BNZ Art Collection.

JOHN WALSH (born 1954) *Artist on the foreshore*, 2004, oil on board, 795 x 1215mm, private collection. Photograph by Helen Mitchell, courtesy of Janne Land Gallery, Wellington. *One at a time, please*, 2005, oil on board, 900 x 1200mm. Courtesy of the artist. Further Reading *Nanny Mango* (a children's book), John Walsh, 2000.

HARRY WATSON (born 1965) *George*, 2004, coloured woodcut, 162 x 130mm; *Henry Williams's Reliable Quills*, 2004, painted wood, 415 x 275 x 115mm, private collection.

MARILYN WEBB (born 1937) *Ngauruhoe Snow – Aunt Daisy*, from 'Taste Before Eating' series, 1982, monotype, 612 x 920mm, collection of Dunedin Public Art Gallery. Further Reading *Marilynn Webb: Prints and Pastels*, Bridie Lonie and Marilynn Webb, 2003.

A. LOIS WHITE (1903–84) *Design*, c. 1944, varnished watercolour, 350 x 300mm, BNZ Art Collection, reproduced by permission of the Estate of A. Lois White. Further Reading *By the Waters of Babylon: The Art of A. Lois White*, Nicola Green, 1993.

ROBIN WHITE (born 1946) *I am doing the washing in the bathroom*, 1984, from 'Beginner's Guide to Gilbertese', hand-coloured woodblock print, 150 x 200mm, private collection. Further Reading *Robin White: New Zealand Painter*, Alister Taylor and Gordon H. Brown, 1981.

BRENT WONG (born 1945) *Town Boundary*, 1969, oil on hardboard, 970 x 1220mm, BNZ Art Collection.

M. T. (TOSS) WOOLLASTON (1910–98) *Figures from Life*, 1936, oil and charcoal on paper, 627 x 478mm, collection of Auckland Art Gallery Toi o Tamaki, gift of Mr Colin McCahon, 1954. Further Reading *Toss Woollaston*, Gerald Barnett, 1991.

GENERAL BOOKS

Another 100 New Zealand Artists, Warwick Brown, 1996.

Art New Zealand website, edited by William Dart: www.art-newzealand.com

The Collections: Christchurch Art Gallery Te Puna o Waiwhetu, ed. Anna Rogers, 2003.

Contemporary New Zealand Painters A–M, Marti Friedlander, Jim Barr and Mary Barr, 1980.

Contemporary New Zealand Painting, volumes 1, 2, 3, 4, Elizabeth Caughey and John Gow, 1998–2005.

The Guide, Auckland Art Gallery Toi o Tamaki, 2000.

Headlands: Thinking through New Zealand Art, ed. Mary Barr, 1992.

How to Look at a Painting, Justin Paton, 2005.

Icons Nga Taonga: From the Collections of the Museum of New Zealand Te Papa Tongarewa, 2004.

Lands and Deeds: Profiles of Contemporary New Zealand Painters, Gregory O'Brien (with photographic portraits by Robert Cross), 1996.

Look This Way: New Zealand Writers on New Zealand Artists, ed. Sally Blundell, 2007.

A Nest of Singing Birds: 100 Years of the New Zealand School Journal, Gregory O'Brien, 2007.

New Zealand Art: A Modern Perspective, Elva Bett, 1986.

New Zealand Painting: A Concise History, Michael Dunn, 2003.

New Zealand Women Artists, Anne Kirker, 1986.

100 New Zealand Paintings, Warwick Brown, 1995.

Pacific Parallels: Artists and the Landscape in New Zealand, Charles C. Eldredge with Jim Barr and Mary Barr, 1991.

Paradise Now? Contemporary Art from the Pacific, Melissa Chiu and others, 2004.

Prints and Printmakers in New Zealand, Peter Cape, 1974.

Speaking in Colour: Conversations with Artists of Pacific Island Heritage, Sean Mallon and Pandora Fulimalo Pereira, 1997.

Taiawhio: Conversations with Contemporary Maori Artists, volumes I and II, edited by Huhana Smith, 2005 and 2007.

This Thing in the Mirror: Self Portraits by New Zealand Artists, Claire Finlayson, 2005.

200 Years of New Zealand Landscape Painting, Roger Blackley, 1989.

200 Years of New Zealand Painting, Gil Docking, 1990.

Welcome to the South Seas: Contemporary New Zealand Art for Young People, Gregory O'Brien, 2005.

ACKNOWLEDGEMENTS: Many thanks to the artists, collectors, galleries and institutions who generously helped with this publication. I am especially grateful to Susanna Andrew, Fergus Barrowman, Don Bassett, Jenny Bornholdt, Brendan O'Brien, Emma Bugden, Robbie Burton, Margaret Cahill, Mary-Jane Duffy, Sarah Farrar, Kathlene Fogarty, Rob Gardiner, Sue Gardiner, Norman Heke, Roger Horrocks, Vicki Hughes, Mark Hutchins, Penny Jackson, Shelley Jahnke, Janne Land, Hamish McKay, Peter McLeavey, Bill Manhire, Nadine Milne, Penney Moir, Jenny Neligan, Paula Newton, Roger and Helen Parsons, Craig Potton, Richard Reeve, Jane Sanders, Neil Semple, Deborah Smith, Roger Steele, Lara Strongman, Margaret Styles, Fiona Sullivan, Jill Trevelyan, Linda Tyler, Tim Corballis at Alexander Turnbull Library, Geoffrey Heath at Auckland Art Gallery, Natasha Mansbridge at Canterbury Museum, Tim Jones at Christchurch Art Gallery, Genevieve Webb at Dunedin Public Art Gallery, Helen Telford at the Govett-Brewster, Natalie Poland at Hocken Collections, Cherie Meecham and Ann Somerville at Rotorua Museum of Art & History, Richard Wotton and Greg Donson at the Sarjeant Gallery, Nicola Jennings at Te Manawa, Kate Button and Jo Moore at the Museum of New Zealand Te Papa Tongarewa, Bev Eng at TheNewDowse and the staff of City Gallery Wellington. Thanks to Ruth Park (whose story 'The Shaky Island' appeared in the *School Journal* in 1947) for making me think a little harder about these Shaky Islands. The team at Auckland University Press – Elizabeth Caffin who, as editor, commissioned the book and her successor Sam Elworthy who saw it through production. Anna Hodge, Annie Irving and Christine O'Brien. Katrina Duncan for her design; Sarah Maxey for her work on the cover. Major thanks to Felix, Carlo, Jack-Marcel Haddow, Geraldine Wilkins and Greta Wilkins for their valuable advice and impeccable judgements. *Gregory O'Brien*

First published 2008. Reprinted 2009.
Auckland University Press
University of Auckland, Private Bag 92019, Auckland, New Zealand
www.auckland.ac.nz/aup

ISBN 978 1 86940 404 8

Printed by Kyodo Nation Printing Services, Thailand

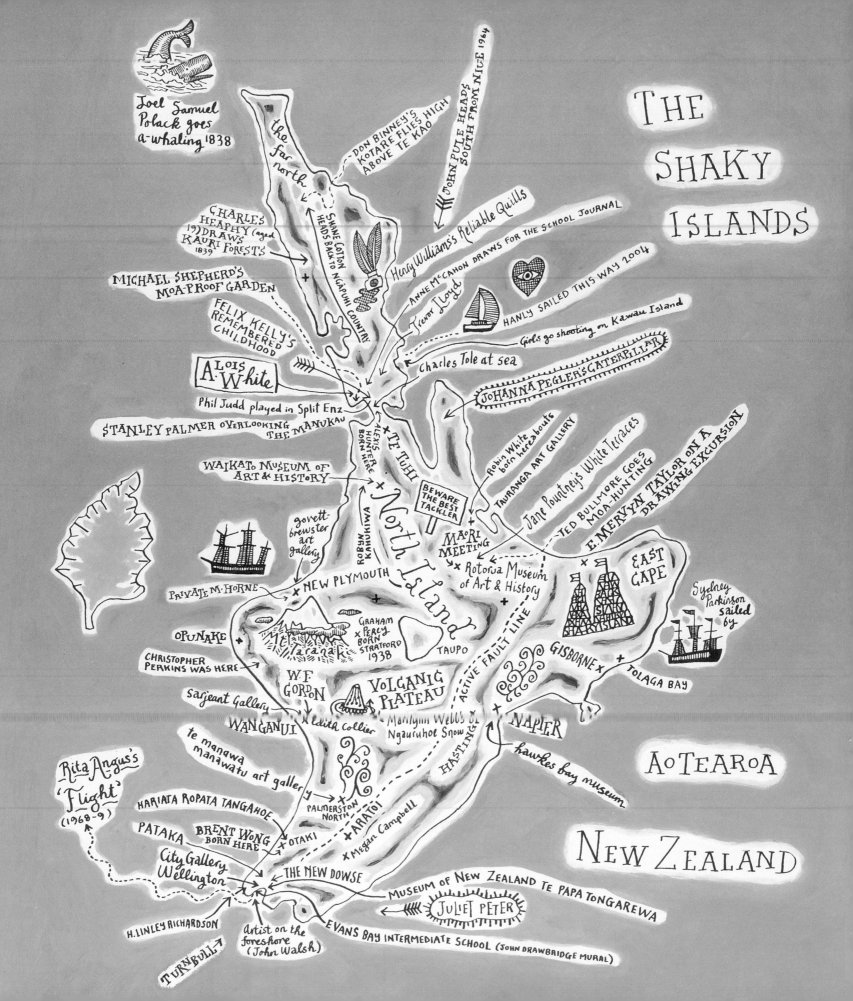